JEAN COCTEAU

© 2003 Assouline Publishing for the present edition
601 West 26th Street, 18th floor
New York, NY 10001, USA
Tel.: 212 989-6810 Fax: 212 647-0005
www.assouline.com

First published in Great Britain in 1998
by Thames and Hudson, Ltd, London.
Copyright © 1998 Éditions Assouline, Paris.

Translated from the French by Jane Brenton

Printed by Grafiche Milani (Italy)

ISBN: 2 84323 603 7

JEAN COCTEAU

PATRICK MAURIES

ASSOULINE

For Andreas Hohl

'The knack is art.'
Jean Cocteau, *Portraits-Souvenir*

Jean Cocteau was born into a well-established and respected bourgeois family in Maisons-Laffitte on 5 July 1889. In one of his many carefully fashioned accounts of his life, there exists a description of his mother as a 'madonna swathed in velvet, smothered in diamonds, bedecked with nocturnal plumes, a glittering chestnut tree, spiked with rays of light, tall, abstracted, torn between the last promptings to be good and one last look in the mirror'.

Cocteau had less to say of his father, who committed suicide while his son was still no more than a child. There was talk of financial difficulties, but Cocteau, or at any rate his fiction-writing alter ego, hinted in *Le Livre blanc* at homosexuality as his father's reason for doing away with himself; this leaning was supposedly encouraged by the abstracted narcissism of his wife (unless, of course, cause and effect ought to be reversed).

Some have seen this unhappy union as the source of Cocteau's Eros, the particular orientation that governed his life and made him the loving mentor of a succession of young ephebes in a re-enactment of the father–son relationship. His inspiration was inextricably linked not only to his family but to his milieu and the culture of a *fin-de-siècle* capital, which he ultimately helped to render obsolete ('I was born a Parisian, I speak like a Parisian, I have a Parisian accent').

Young Jean was not a success at school, something which became part of his personal mythology and confirmed him in a role which was to remain his for the rest of his life, that of the outsider: the whipping-boy of

the Surrealists and André Gide, a media personality before his time, an artist whose works would in the end prove to have been no more than a pale reflection of his life…Yet, as we will see, his deficiencies may have been more seeming than real.

his first book, *La Lampe d'Aladin*, was written when he was sixteen. Some of these poems had been read, or rather declaimed, by the actor De Max at the Théâtre Fémina. Marked by the portentousness of their age, of the circles in which he moved (figures such as Catulle Mendès, Edmond Rostand, Lucien Daudet, Jules Lemaître, Anna de Noailles and Marcel Proust), they were old before their time, and Cocteau was later to forbid the publication of any new edition. He did the same with his next two titles, *Le Prince frivole* and *La Danse de Sophocle*, which he came to see as hopelessly enmeshed in turn-of-the-century folklore.

He was not unaware that his life's work had begun with a recantation, the result of his fascination with influential places and people, the manners and topics of the moment. And indeed in any *appreciation* of Cocteau's work, fashion must play a part, because the two are interdependent.

His *annus mirabilis* was 1913, the year when he met Diaghilev, and the famous remark was uttered that became the watchword of his whole existence ('Amaze me'); it was also the year of his final break with the so-called modern style, in favour of the exclusive celebration of modern life. Cocteau's collaboration with Paul Iribe, and then with Picasso three years later, was to set the seal on his new allegiance and mark a fresh start. In *Le Potomak* (1919), one of the singularities of Cocteau's style was already apparent, his felicitous choice of characters' names (Persicaire and Argémone, soon to be followed by Cégeste and Heurtebise). The *Discours du grand sommeil* (1925) admits of a few typographical experiments, but, beyond any shadow of doubt, Cocteau's break with the past had been made in 1917, while he was working on the ballet *Parade* with

Satie and Picasso. This was the time of the 'call to order', the return, influenced by the whole Mediterranean experience, to a clearly laid-out tradition, a reclaimed classicism.

The works that immediately followed proclaimed Cocteau's new credo: *Les Mariés de la tour Eiffel* (for Rolf de Maré's Ballets Suédois); *Le Bœuf sur le toit* (with Dufy and the Fratellinis); and the short manifesto piece *Le Coq et l'arlequin*. Each orchestrates the same themes: the rejection of woolly sentiment, of the sublime, of Symbolist approximation; the repudiation of Wagnerian excess or Debussian tremulousness; the refusal to tolerate the esotericism of the new poetics. All of these are forms of 'fudge', or *empoissement*, as Barthes would have termed it a few years later – the absolute antithesis of Mediterranean clarity, of Satie's ironic *brevitas*, of the Bizet extolled by Nietzsche, of a realism 'more real than reality'. A collection of poems (*Vocabulaire*, 1922); an essay (*Le Secret Professionnel*, 1922); his first novel (*Le Grand Ecart*, 1923): these are early variations in the manner that was to remain Cocteau's to the end, and in which he found his voice.

an extraordinary encounter, the first of many, provided the confirmation of his new aesthetic direction, giving it, quite literally, bodily form, as well as enabling Cocteau to develop his theory. In 1919, he was introduced by Max Jacob to Raymond Radiguet, then barely sixteen years old. Cocteau helped Radiguet to produce two masterpieces, *Le Diable au corps* and *Le Bal du comte d'Orgel*, and then proceeded to transform the youth into the figure of an angel, the prototype of the dazzling adolescent, shining with integrity, careless of the rules – more precisely the rules of commerce that govern a literary property – and all by virtue of supreme rigour and sovereign mastery.

Radiguet died prematurely, ensuring his mythic status, and making him the very symbol of youthful beauty snatched by fate. A Rimbaud-like figure, he seemed consumed by the internal fires of a total and

instantaneous mastery of expression, the intensity of which seemed impossible to sustain. In him, human poignancy went hand in hand with aesthetic principle. Death was merely the other side of the coin of youth. Cocteau's life appears to have been indelibly marked by this experience. (Several years later, he would try to rediscover an echo of that early grace in Jean Desbordes who, like another dazzling young man, Marcel Khill, was to die in the Second World War.) Overcome by the shock of Radiguet's death, Cocteau turned to opium. Later, in a famous account (*Opium*, 1930), he described his addiction and detoxification treatment.

Fleeing the capital, he took refuge at the Hôtel Welcome at Villefranche-sur-Mer, a place that came to hold a special significance for him as the locus of his love for boys and drugs, sun-worship, a Nietzschean Mediterranean and the joys of writing.

t he period at the Hôtel Welcome established another of Cocteau's strategies for escaping the intolerable, namely his conversion to Catholicism in 1925 at the instigation of Jacques Maritain, with whom he corresponded and exchanged writings. The cult of pleasure and bodily enjoyment, an uncompromising philosophy of immanence and sensuality raised to the level of a principle, rapidly supplanted his meta-physical explorations. A volume by Jean Desbordes, *J'adore*, published in June 1928, summed up the new credo and created a scandal.

To coincide with *J'adore*, Cocteau published a short volume that was very hard-hitting for its day, a description of his discovery of sex and various subsequent adventures and encounters in which myth and biography are interwoven. In the pages of *Le Livre blanc*, his schoolboy loves and classmate Dargelos figure next to sailors in a brothel in Toulon, all prey to the indecisions of the narrator. The dry tone and the accuracy of its obser-vation rescue this text, whose authorship Cocteau did not acknowledge until much later, from the bathos that characterizes much 'erotic prose'.

the publication of *Orphée* and *Opéra* in 1927 began an exceptionally productive decade, in the course of which Cocteau introduced the characters of his mythic world one by one. In *Opéra* we learn the key to his poetics:

> *Accidents du mystère et fautes de calculs*
> *Célestes, j'ai profité d'eux, je l'avoue.*
> *Toute ma poésie est là: je décalque*
> *L'invisible (invisible à vous).*

[Chance happenings in the mystery and failures in heavenly calculations,/I have profited from, I confess./All my poetry is in that: I trace what is invisible (invisible to you).]

In *Les Enfants terribles* (1929) we find an echo of the characters and situations detailed in *Le Livre blanc*; yet although the objectives of both books were the same, *Les Enfants terribles* was published to huge acclaim while its forerunner was private and remained a secret. *Les Enfants terribles* was hailed by the critics and greeted as the book that summed up its generation. The two main characters, Paul and Elisabeth, were based on another young 'Greek god', Jean Bourgoint, and his sister Jeanne who, behind closed doors, led a life of unconventional sexuality that fascinated Cocteau. The same mix of private worlds, of pathological jealousy, the suspension of reality, and of passionate extremes characterizes the dramatic counterpart of the novel, the play *Les Parents terribles*, written ten years later, and inspired by the life of Jean Marais.

La Voix humaine, which remains Cocteau's most performed play, exploits a similar tension, one which exists between an actress performing a telephone monologue and her absent lover, who is on the point of leaving her (the performance of the play by Berthe Bovy on 1 February 1930 provoked an outburst from Paul Eluard, who shouted, 'It's obscene, that's enough, that's enough, it's Desbordes you're ringing'). Cocteau never expressed himself better than when he was translating and transposing the spare style of classical tragedy.

Persuaded by the Noailles, he tried his hand at film-making, embarking on *Le Sang d'un poète* (1930) with the same ingenuousness, the same taste for inspirational invention that was to illuminate all his subsequent 'cinema poetry', from *Orphée* (1950), via *La Belle et la Bête* (1946), to *Le Testament d'Orphée* (1960). While apparently no more than a secondary or contingent form of expression, Cocteau's cinematic ventures were more influential than all of the rest of his work put together, introducing his imagery to a worldwide audience.

During the thirties, more or less at a stroke, Cocteau charted his intellectual territory, reimposing a 'Greek' mythology that lent itself harmoniously to his linear aesthetic. Having adapted *Œdipus Rex* some ten years earlier, modernized Sophocles' *Antigone* and collaborated (not without problems) with Stravinsky and Diaghilev on another *Œdipus Rex*, in 1932 he wrote *La Machine infernale*, a play not performed until 1934. Unsurprisingly, his fiercely frivolous and Slav-accented Jocasta was seen as an incarnation of the maternal figure; but Cocteau brought out the elements that make this tale a tragedy of unknowingness, focusing on the tension between the knowing and the desire not to know, the apprehension of a fundamental misapprehension – the 'unconscious' blindness of the mother matched by the deliberate blindness of the son.

And the image of a small white sphinx is a thread that runs right through Cocteau's work. In his last film, *Le Testament d'Orphée*, a sphinx appears once more beside Cocteau, flapping its raffia wings, as he walks alongside a wall, like some ultimate allegory of knowledge in ignorance, clearsightedness in blindness, one of Cocteau's obsessional themes.

At about this time, early in 1932, Christian Bérard decorated the walls of one of Cocteau's first retreats (a small apartment at 9 rue Vignon) with an image of the symbolic encounter of Œdipus and the Sphinx. With its rudimentary furnishings, pinned-up photos, a few sculptures (including

the admirable portrait of Radiguet by Lipchitz) and a handful of drawings and prints, this environment was one of the earliest expressions of that genius of place exhibited by Cocteau throughout his life, revealing his need to settle in one place and escape the hotel bedrooms that had hitherto been his lot.

These years were punctuated by a love affair with Nathalie Paley, the seduction of a new ephebe (Marcel Khill had appeared on the scene) and the publication of a play on the myth of the Holy Grail, *Les Chevaliers de la Table Ronde*. Financial difficulties impelled Cocteau to take up journalism. For *Le Figaro*, he produced a few pyrotechnic exercises in nostalgia, descriptions of the society of 1900–14, Proust and Montesquiou, Polaire and Colette, under the title *Portraits-Souvenir*. Cocteau's apparent desire to settle yielded to a chance suggestion by Marcel Khill that he should follow the itinerary of *Around the World in Eighty Days*, and publish the finished account. As Roger Lannes elegantly summed it up, 'the manuscript of the *Essai de critique indirecte*, an accumulation of old cigarette packets, tennis shoes, gloves and ashtrays, for the poet wrote on everything and anything, having been put into a bag and presented to a lady, and the apartment at the rue Vignon having been broken up and its contents dispersed, the poet set off'.

●

In June 1937, Cocteau, having agreed to attend a performance of his *Œdipe Roi* staged by the pupils of the Cours Raymond Rouleau, was invited to sit in on the auditions. It was an 'accident du mystère' – he had no idea that this simple formality would lead to one of the key encounters in his life. Jean Marais (like Edouard Dermit after him) was another manifestation of the shining figure which haunted Cocteau, the very incarnation of the young man with the clear gaze who had appeared in his drawings from the outset. In Cocteau's mythological world, he is clad in nothing more than a few strips of cloth artfully knotted by Coco

11

Chanel, enacting the role of the chorus in *Œdipe*. Cocteau was forty-eight, Marais twenty-four, and their relationship, right up to the time of Marais' death, was destined to be a catalyst for both hatred and respect, enjoying public recognition (without being spoken of in so many words) at the heart of a society certainly not distinguished by its libertarian attitudes.

The image of which Marais was the focus might be described in the lines Cocteau devoted to the Dargelos myth in *Portraits-Souvenir*: 'I would prefer him to dwell in the darkness where I replaced him with his constellation, for him to remain, for me, the archetype of what cannot be known or taught or judged, analysed or punished, of all that makes a human being an individual, the prime symbol of the primitive forces that inhabit us (which the social machine tries to kill in us), a symbol which, beyond good and evil, guides the individuals whose example is our consolation for being alive.'

The young man's artlessness and calm were given dramatic form, successively, as the Galahad figure in *Les Chevaliers de la Table Ronde*, and then in *Les Parents terribles*, performed in December 1938, which, as we have seen, was widely believed to contain echoes of Cocteau's own past. He wrote two short plays at about this time, *La Machine à écrire*, inspired by a provincial news story, and *Le Bel Indifférent*, performed by Paul Meurisse and Edith Piaf.

In *Les Monstres sacrés*, a co-production with Bérard, yet another jealous and tyrannical female figure featured, a prima donna in the style of Réjane or Sarah Bernhardt who dominated the stage; the part was performed by Yvonne de Bray. The première took place on 17 February 1940; four months later, the German Occupation had begun. Cocteau can scarcely be said to have distinguished himself, either by his actions or the soundness of his judgment, during the war years. A reading of the posthumously published *Journal sous l'Occupation (1942–1945)* is instructive in this and other respects. Cocteau's claims to independence and his desire to align himself with neither side but instead to rely on his own authority required a political intelligence which he simply did not possess. Inopportune praise for the sculptor Arno Breker, whose supermen

were much admired by Hitler, was to cast a lasting shadow over his reputation – the ultimate illustration of his poverty of judgment.

Yet Cocteau was subjected throughout his life to criticism from the far right, which saw in him the incarnation of corrupt morals and the betrayal of those 'family values' that are the forcing ground of Fascism. He was the victim of numerous attacks, verbal and physical; there was a famous quarrel in which Jean Marais avenged him by thrashing the critic Alain Laubreaux, author of a violent attack in the columns of *Je suis partout*. Cocteau feared harassment when the Liberation came, but escaped blame partly because of his minimal involvement, and partly because of the heroism of Jean Marais, who had enrolled in the Free French Forces.

Renaud et Armide, written in just seventeen days in August 1941, and *L'Aigle à deux têtes*, performed in 1946, are companion pieces in different keys on the theme of forbidden passion and the equation of love and death. The first play, inspired by Tasso's *Gerusalemme liberata*, is a virtuoso exercise in alexandrine composition with a Racinian flavour; the second, based on the relationship between Louis II and Elizabeth of Austria, is linked in Cocteau's interpretation to Kleist and other historical figures who 'for want of being able to create a masterpiece longed to become one'.

But it was the cinema that truly *carried* Cocteau's work during this decade. In 1942, he collaborated on and played the title role in a Serge de Poligny film, *Le Baron fantôme*. The following year he reworked the myth of Tristan and Isolde for Jean Delannoy in *L'Eternel Retour*, performed by Madeleine Sologne and Jean Marais; the film enjoyed considerable success, and became almost a social phenomenon, even influencing fashion on the street. The extent of his success enabled him to risk making a film of his own, the first since *Le Sang d'un poète*. This was *La Belle et la Bête*, after a story by Madame Leprince de Beaumont and much praised for its

lavish sets and costumes (by Christian Bérard), its haunting score (by Georges Auric), superb make-up (by Arakelian), the luminous glades, and the menacing *sfumato* that envelops the film and creates a nebulous landscape that may be a garden or enchanted forest, inspired by Gustave Doré and Romantic imagery. Just as Cocteau intended (his diary of the shooting period, published later, confirms this), the miraculous balance of each contribution to the film was to make *La Belle et la Bête* one of his best known and most effective films (the cinema of Jacques Demy in particular would be inconceivable without such a precedent).

Cocteau followed up this success with film versions of *L'Aigle à deux têtes* (1947) and *Les Parents terribles* (1948), but it was not until *Orphée* in 1949 that he was able to work that particular magic again, bringing to his film an intensity derived from its theme of death: a similarly funereal enchantment characterizes *Le Testament d'Orphée*, the work that brought his cinematic career to a close in 1959.

apart from a long series of poetic works (*Léone*, 1945; *La Crucifixion*, 1946; *Le Chiffre sept*, 1952; *Apoggiatures*, 1953; *Clair-Obscur*, 1954), the late forties and early fifties were largely given over to essay-writing. *La Difficulté d'être* was a particular success. In these short pieces, autobiographical recollections jostle with general reflections on life, and the retrospective tone is leavened by a positive willingness to embrace fate, a sunny stoicism. The *Journal d'un inconnu* and the *Démarche d'un Poète*, published in 1953, and *La Corrida du 1er mai* (1957), constitute the other elements in this autobiographical sequence, perhaps the inevitable consequence of a life that was beginning to close in on itself.

The last decade of Cocteau's life was marked by drawing and painting: typically, he produced many variations on the same motif, executing series of wall paintings for the villa of his friend Francine Weisweiller

(Santo-Sospir, 1950); the chapel of Saint-Pierre at Villefranche-sur-Mer (1956); the Registry Office at the town hall in Menton (1957); the chapel of Saint-Blaise-des-Simples at Milly-la-Forêt (1959); and Notre-Dame-de-France in London (1959). Tapestries, paintings and pottery completed the extensive output of this multi-talented virtuoso, whose range and freedom of expression appear in an increasingly positive light with the passage of time.

Cocteau published his last anthology of poems, *Le Requiem*, in 1962. It contained two knowingly premonitory lines, destined to be much quoted: 'Il est juste qu'on m'envisage/après m'avoir dévisagé' (It is only right you look me in the face/having disfigured me). He died at Milly-la-Forêt on 11 October 1963, one last admonition written on his tomb: 'I am still with you.' In his latter years he had become fascinated with UFOs (calling them 'saucers') and claimed he was the first 'parapsychological' poet.

●

It has been said that Cocteau, probably more than any other writer of his generation, abandoned himself to the currents of fashion, ebbing and flowing with its tides. As far back as the thirties, his future exegetist Roger Lannes, writing in a private journal (published posthumously in the *Cahiers Jean Cocteau*, vol. 10), dismissed him as a genius who had had his day, searching for fresh pastures in which to revive his reputation (which Lannes believed himself capable of rivalling).

Cocteau, then, was one of the first examples of media overexposure (a condition he might be said to have shared with the Sitwells in England, and Salvador Dalí). His love of the limelight (and his love of being praised) aroused the hatred and envy of not only Gide but the Surrealists, provoking descriptions of him as a craven opportunist and inconsistent stylist.

A perfect example of this interpretation of Cocteau's life and work exists in one of the *Lettrines* by Julien Gracq: 'What makes Paris fall at his feet is, when all is said and done, his frame of reference, and his standard metre: as you go through this little book [*La Difficulté d'être*], you realize that all the

significant moments in his life, or almost all, are Parisian *performances*, his own or those of others […] With this work, there seems not the slightest chance that time, as happens with great works, will shed new light upon it – with him, ever since he was born, it was always stage lighting anyway – or admit of any other viewpoint' (*Lettrines*, Paris, Corti, pp. 127–8).

Such a reading, predictable and widely shared though it is, is a nonsense: it condemns Cocteau's work for *being* something it was in fact *about*. 'To live on earth, you must follow the fashion, even when your heart isn't in it,' declares the hero of *Le Grand Ecart*. Cocteau was fascinated by the cyclical rise and fall so characteristic of fashion, and the way fashion dramatizes the transience of things ('Fashion dies young, which is what makes its frivolity such a serious matter'). The image or mirage vanishes when its source disappears. But it is worth remembering that now, thirty-five years after his death, Cocteau's work is more current, and more potent, than that of many of the established writers who were his contemporaries.

a seeming paradox runs as follows: like Wilde, whose French incarnation he is often considered to be, Cocteau put more of his genius into his life than his work ('Cocteau's masterpiece was his own life,' wrote Lannes in 1949), and in so doing gained access to a wide audience. He was, as everyone agreed, a consummate talker, an improviser who was literally transported by language – although as a writer he was able to fix these transports on the page only imperfectly. Like his friend Louise de Vilmorin, he belonged to the narrow tradition of eighteenth-century salon culture, of which Fontenelle was the prime representative (it was from him that Cocteau borrowed his 'difficulté d'être'). As we will see, Cocteau was indebted to Fontenelle in several other respects as well.

As a talker, he was distinguished by his acute awareness of the impermanence of things: with him, nothing escaped the flow of language, or failed to be captured in the perpetual to and fro of conversation. He identified

himself easily with a changing world of instantaneity and short-termism: 'Without shop windows, posters, music-halls, shops and magazines, the new beauty would age slowly and not well' (*Essai de critique indirecte*, Paris, Grasset, 1932, p. 204). In this he was, therefore, more radical than even the Surrealists, who sought redemption in the archetype, in the timeless lexicon of dreams.

A contemporary not only of Laurent Tailhade but of Andy Warhol, Cocteau was from the outset conscious of the contingent nature of that 'modernity' to which he clung with all his being, not once succumbing to the illusion of tradition being fulfilled, or redeemed, by the moderns: 'In the same way that the word "modern" has changed its meaning, so that the *modern era* is the period from 1912 and 1930, so too researches and discoveries become dated, at least insofar as research is an aesthetic. Even if a particular discovery were something quite amazing and unprecedented, it would still become dated, because it was achieved through research, and therefore by means of an obsolete aesthetic' (*Essai de critique indirecte*, p. 203).

No doubt this 'postmodern' lucidity, well ahead of its time, explains why Cocteau is now praised by the very people who, had they been his contemporaries, would certainly have attacked him on the grounds that they were the ones in tune with the mood of the times, the true embodiment of the *Zeitgeist*.

The profound *instability* of Cocteau's artistic universe is an expression, or betrayal, of that *relative* view of the world (the exact opposite of someone who puts on airs as a great writer, flatters himself that he is universal, and shores himself up with his stylistic certainty). The 'knack' of his art is that he restricts himself to a 'poor' reality – abandoned materials like rope, straw, plaster or shells – and gives them form; it is a philosophy of inspired improvisation, where anything can be pressed into service for any purpose, while remaining in a precarious state of reality. There are rubber gloves, whose 'snap' becomes a sinister warning, a mirror made of a water surface, a lethal snowball, a hibiscus flower opening in reverse, a length of rope transformed into a necklace...Also the sculpture made of pipe-cleaners that casts its

shadow over his face in a famous photograph; all those interiors, those ephemeral montages that punctuate his life, from the rue Vignon to Milly-la-Forêt, the Palais-Royal to the Villa Santo-Sospir; the circus tricks and fairground illusions he plays with in his films. It is a way of *overexposing* the raw material of existence, making it unreal, the invisible aspect of the day-to-day world, in which things themselves are accorded their due weight and presence. Evidently influenced by Picasso, juggling with Surrealist notions of the *objet trouvé*, Cocteau is also a master of junk poetry, in which the poverty of the materials acts as the source of sophistication (a whole strand of contemporary art is dedicated, after all, to more or less the same pursuit).

'Perfect balance is indispensable, if you are overturning the traditional order,' writes Cocteau in *Le Coq et l'arlequin*. Having once proclaimed the essential apostasy of the twenties, the need for a 'return to order', the rejection of Debussy in favour of Satie, of woolliness in favour of clarity, then, as if to compensate for his supposed inconsistency, Cocteau clung obstinately to his linear aesthetic, his reinvented Greekness, his 'neutral' style. Paradoxically, it meant a return to the French tradition, with Radiguet as his hero. The aims were brevity, line and concision, an economy of means that eradicated and expunged all the *vibrato* of expression. The stylistic criterion was to 'shoot straight' and hit the target; writing was the experience of chance: 'There are poems in which the poet tries his luck; others in which the poet makes it last. Such lucky poems are rare. They flow from the hand like ectoplasm from the medium's mouth. The poet, with one eye shut, controls its fall.'

Cocteau was to return to this paradox over and over again, investing the uncontroversial notion of clarity of expression with contradictory attributes: 'Brevity, precision, promptness, shape, that is all we need to be taken as hermetic writers,' he pleads (on his own behalf) in the *Essai de critique indirecte*.

His graphic works are the most visible expression and testament of this stylistic philosophy: Greek, influenced by both Ingres and Picasso, seeking to reduce things to signs. The drawings, like Picasso's, are 'figures made flesh' (although Cocteau can be slapdash or guilty of kitsch, especially in the late canvases and pastels). But his stylistic world cannot be summed up merely in terms of a bias towards classicism. In fact, it derives from a particular moment in his life, and reflects the choices of a particular milieu, the inspirations of art and fashion, precisely by shattering them. It is, in fact, legitimate to see Cocteau's work as bi-polar, held in equilibrium between the two opposing forces that dominated the cultural history of the first half of the century.

In a letter of March 1954, examining the events of the last thirty years, Jean Hugo cast fresh light on this duality (the text, although not well known, is crucial, insofar as it represents the viewpoint of people who were influential in their time; the letter is reproduced as an appendix to *Le Passé défini*, vol. 3, Paris, Gallimard, 1989, pp. 328–40):

> The half-century that concerns us may be divided, roughly speaking, into two periods: 1925–35, the apogee and decline of the age of Chanel, which succeeded the age of Poiret in 1918; 1935–50, the age of Bérard, which continues to the present.
>
> Age of Chanel:
> Simplicity, asceticism, repudiation of all that is 'becoming', what Cocteau called with reference to Picasso *luxe pauvre*, straight lines, dark colours, evening dresses reduced to uniform shifts of black crêpe de Chine [...]
>
> Age of Bérard:
> Return of the flowing arabesque, the baroque, richness, colours, velvet, satin, flounces, drapes, etc. [...] Architecture by Emilio Terry. Decors by Bérard for the Comtesse Jean de Polignac.

Fleshed-out baroque and the reduction, or restriction, of classicism; two fashions superimposed, two ages, two different rhythms that provided the framework of Parisian style in the first half of the twentieth century: Cocteau provides the clearest expression and best *resolution* of this contradiction. The neutrality of his style is incomprehensible without the voluptuous curve of the volute.

a minor but imposing figure, Cocteau lived his whole life in the shadow of one or other major talent. He was, or wanted to be, perhaps pretended to be, second fiddle to Satie, to Diaghilev, to Bérard or to Picasso (who was not without a certain ambivalence towards him). The eternal Mercutio, his tragic lot was to play out his life in a secondary role. Others have not been slow to see in this biographical leitmotif a reaction to the sudden extinction of his father. And it is probably true that, behind his facility, his impatience, his incessant flow of talk and improvisation, there lay a need to exorcise a void, a nameless violence of which we are all victims. In Cocteau's world, even the sphinx cannot escape its force ('The sphinx, intermediary between gods and men, is manipulated by the gods who pretend to allow it its freedom and whisper to it to save Œdipus, with the sole purpose of destroying him,' he writes in the *Journal d'un inconnu*).

In this respect too, Cocteau was profoundly Nietzschean: 'Since these mysteries are beyond us, let us pretend we are their masters.' The victims of infinite powers, we can only feign control over them; there is no other solution than to pretend, and to know we do so: *amor fati*, Nietzsche called it. It is in this private conviction that the strength of the weak lies, a strength that is *affirmed* in the very act of pretending – for Cocteau by no means accepted this supposed inferiority passively (the pages of his journal, the posthumously published and encoded text that was the repository of his thoughts from the fifties onwards, are sufficient to prove

the point: the record of his successes, albeit somewhat anxious, and the marks of recognition due to them are very much rooted in an often quite childish belief in his own superiority, and his obscurity).

Only an amorous encounter provides a fleeting opportunity to redress the balance; dangerous, free, another force of which one will be the helpless victim, it offers an instant illusion of escape from the powers of destruction, the violence of the real world; this is Cocteau as Pygmalion, to Radiguet, Desbordes and Jean Marais. But the violence, of course, *rebounds* on him, with inevitable force, snatching from him one after the other the young men 'lent' to him by fate.

A new figure appears, whose fascination lies in its ability to resolve the opposing forces in his life, to reconcile the irreconcilable: the figure of the sleeper. A seeming corpse, it is the image of life's resistance, of the body in all its glory, present even in absence, breathing through sharply defined, half-parted lips, wholly given up to silence, the weight of the flesh, the perfect beauty of the moment.

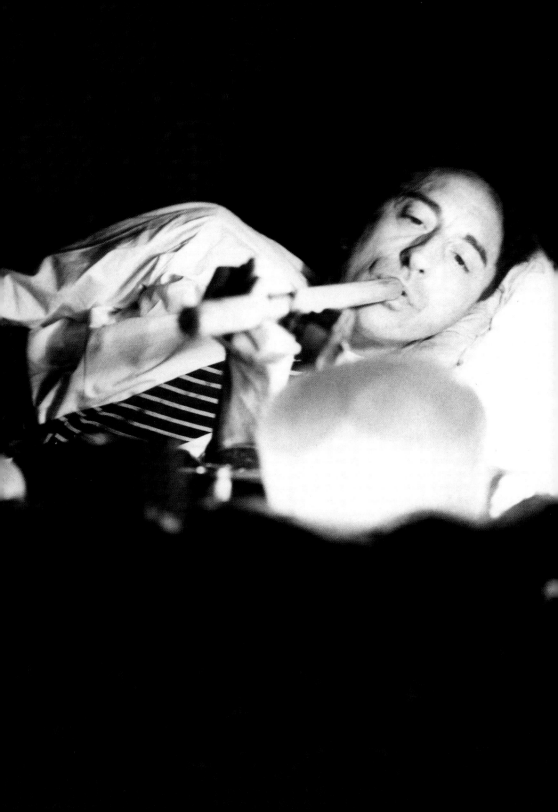

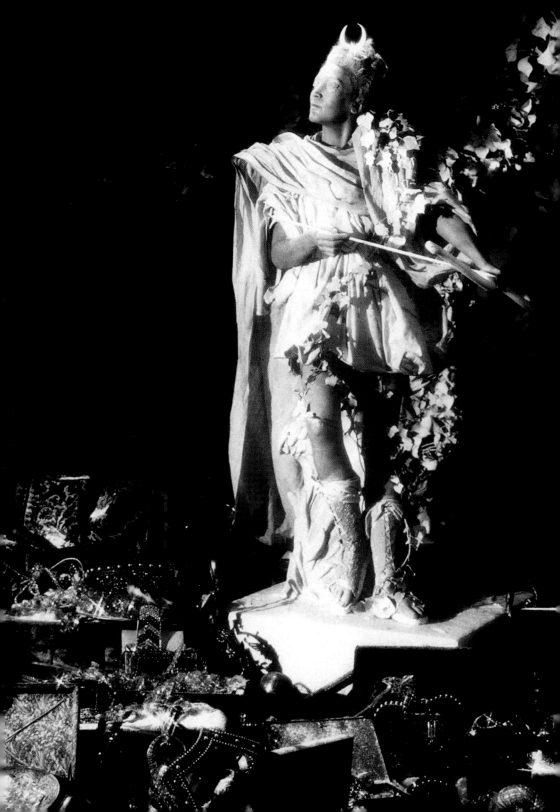

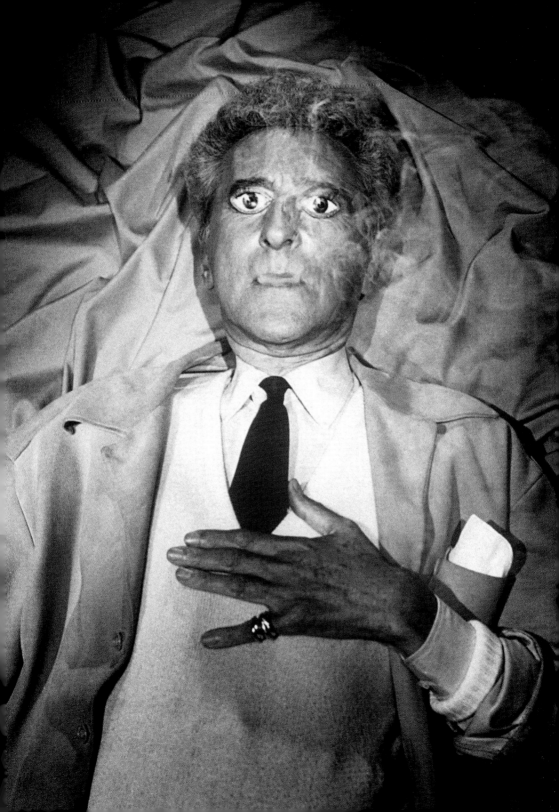

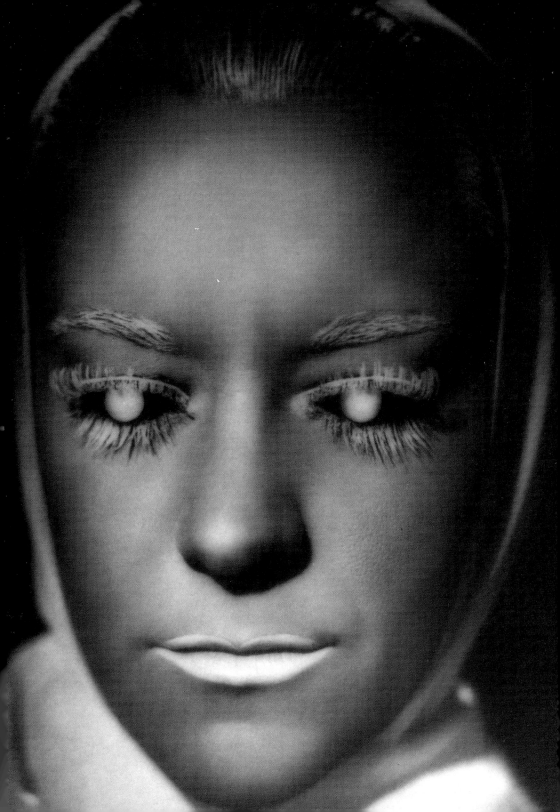

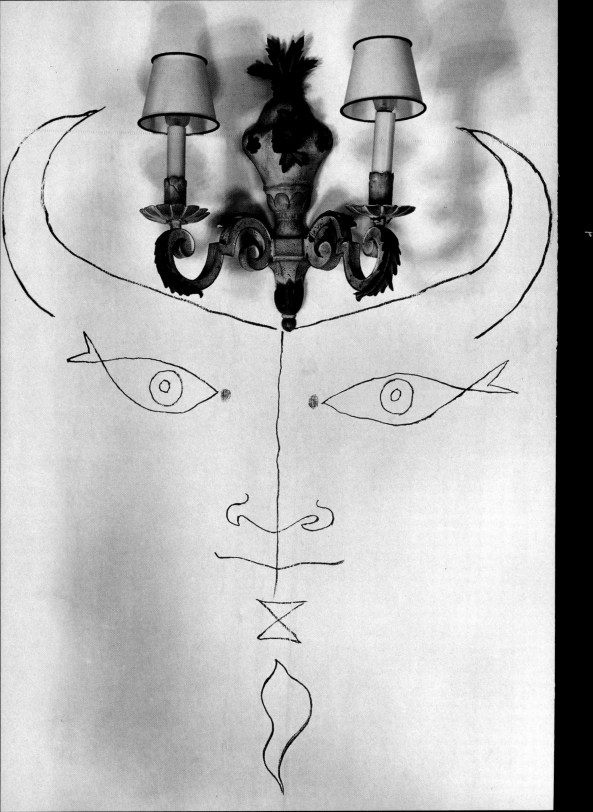

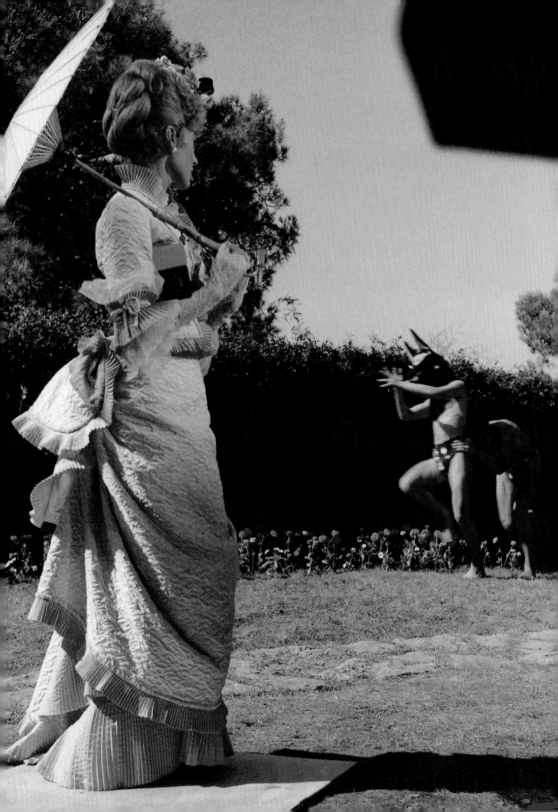

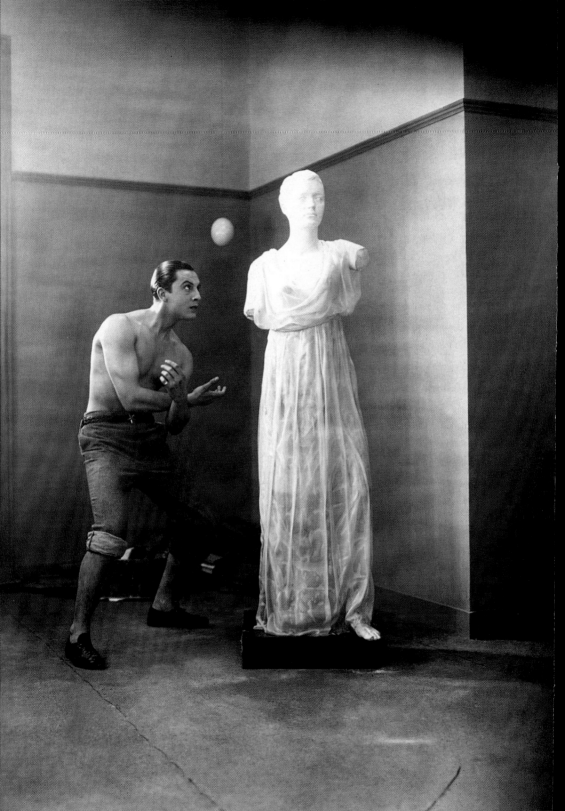

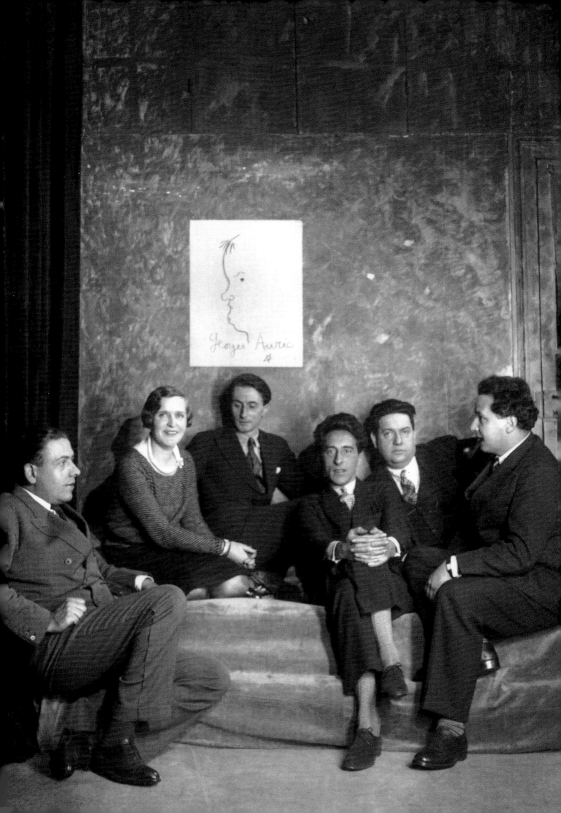

Raymond Radiguet

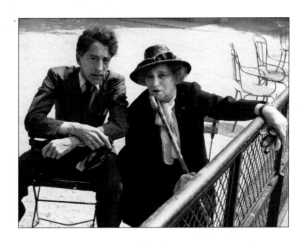

With Colette

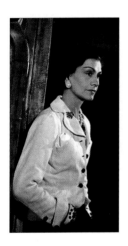

Coco Chanel

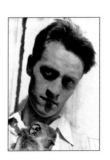

Jean Desbordes

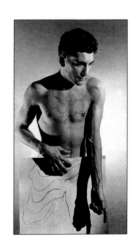

Marcel Khill

Nijinsky and Diaghilev

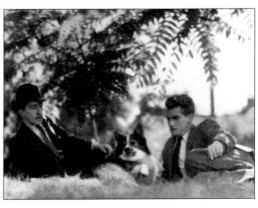

With Jean Marais

Picasso and Stravinsky

Anna de Noailles

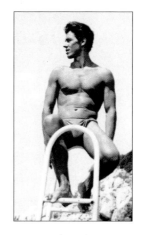

Edouard Dermit

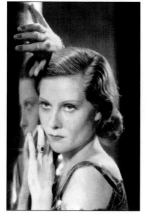

Nathalie Paley

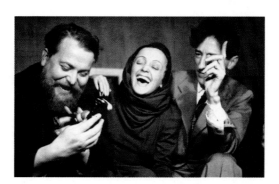

With Christian Bérard and Edith Piaf

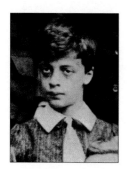

Pierre Dargelos,
as a schoolboy

Francine Weisweiller

Louise de Vilmorin

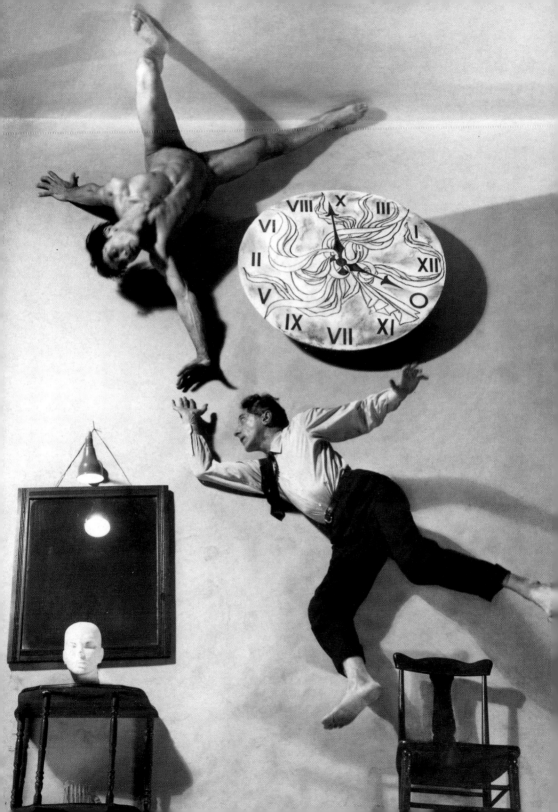

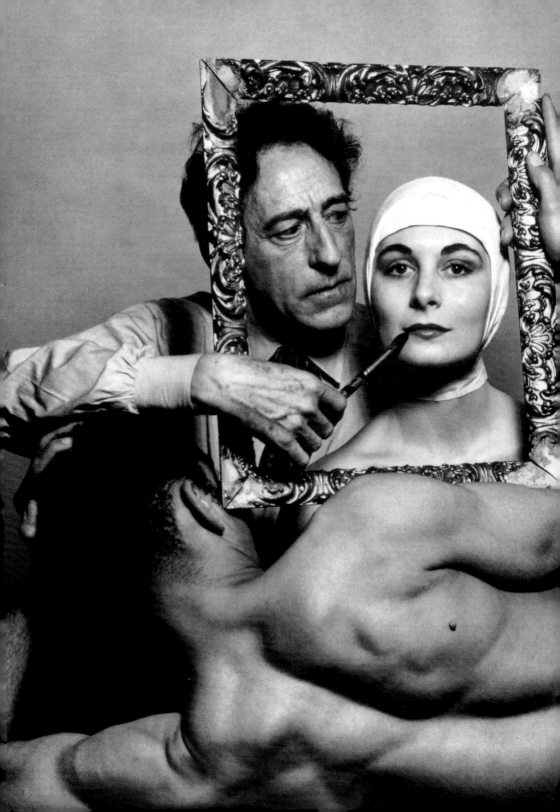

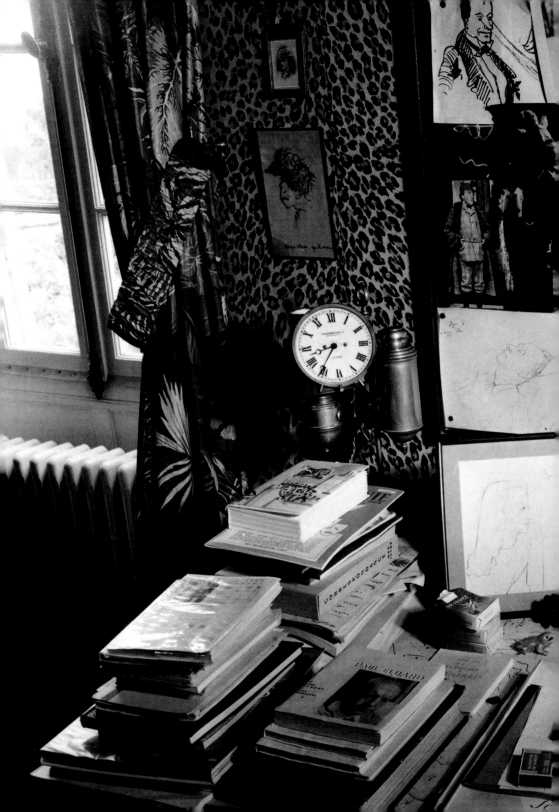

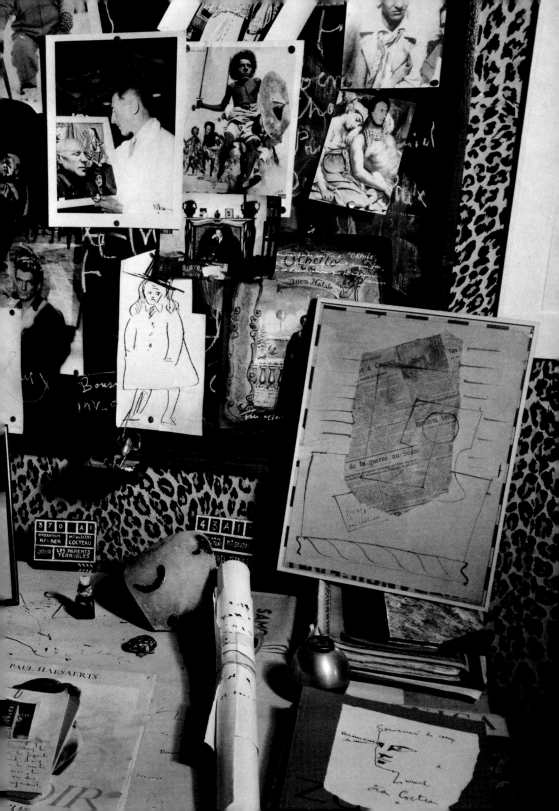

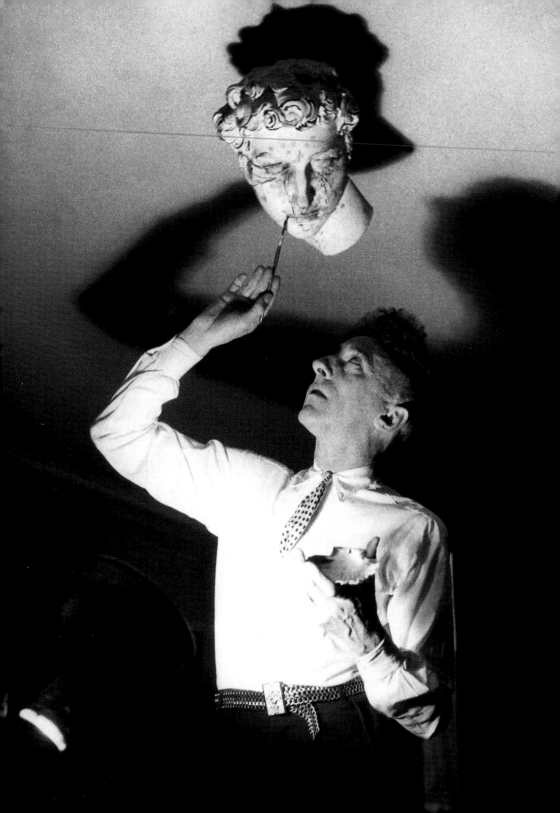

Grasset

Théâtre Complet

Jean Cocteau

*

illustré par l'auteur

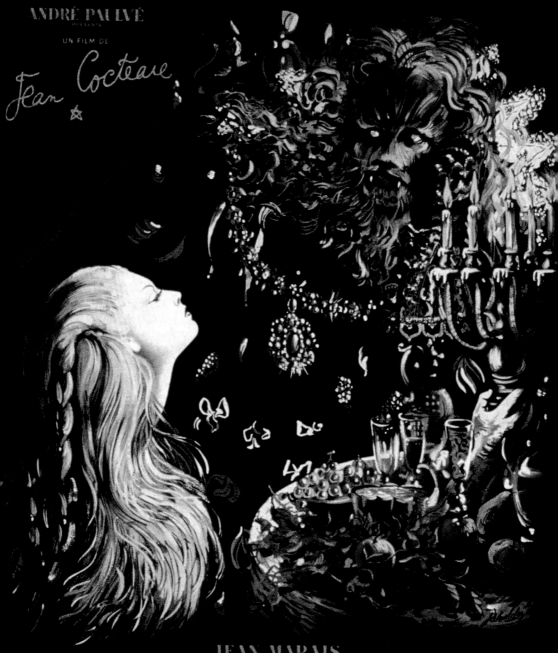

ANDRÉ PAULVÉ
PRÉSENTE

UN FILM DE

Jean Cocteau

JEAN MARAIS
JOSETTE DAY

la BELLE et la BÊTE

HISTOIRE, PAROLES, MISE EN SCÈNE DE **JEAN COCTEAU** D'APRÈS LE CONTE DE MADAME **LEPRINCE DE BEAUMONT**

CHRISTIAN BÉRARD

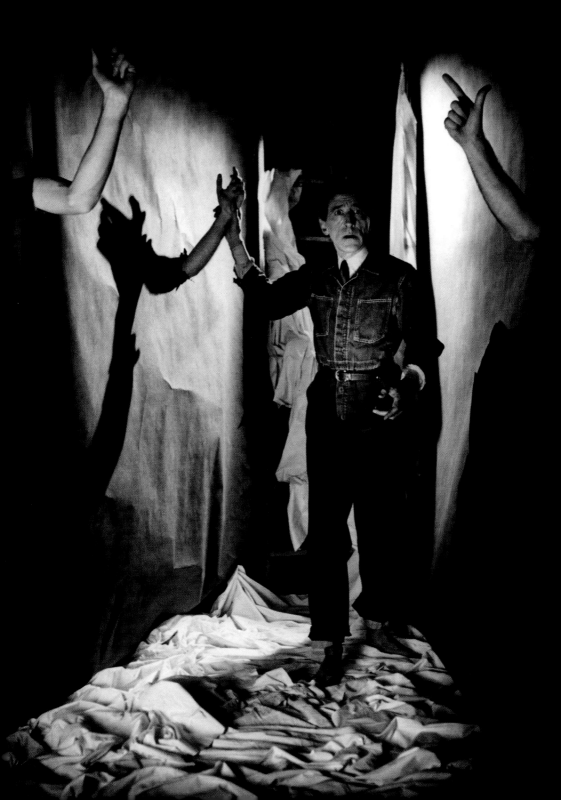

André Paulvé
présente

JEAN MARAIS
FRANÇOIS PERIER
MARIA CASARÈS
MARIE DÉA

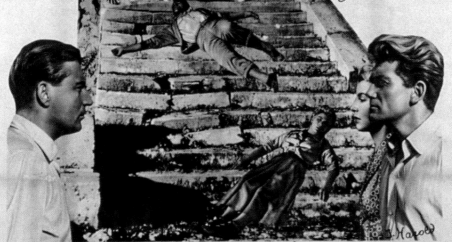

DANS UN FILM
ÉCRIT ET RÉALISÉ PAR

Jean Cocteau
＊

ORPHÉE

HENRI CREMIEUX . GRECO . ROGER ·BLIN . EDOUARD DERMITHE
avec
PIERRE BERTIN et JACQUES VARENNES

PRODUCTION
ANDRÉ
PAULVÉ
ET LES FILMS
DU
PALAIS
ROYAL

MUSIQUE DE
GEORGES AURIC

DIRECTEUR DE LA PHOTOGRAPHIE
NICOLAS HAYER

DÉCORS DE
D'EAUBONNE

COSTUMES DE
MARCEL ESCOFFIER

DIRECTEUR DE PRODUCTION
EMILE DARBON

AFFICHES GAILLARD PARIS 30.0210

DISTRIBU

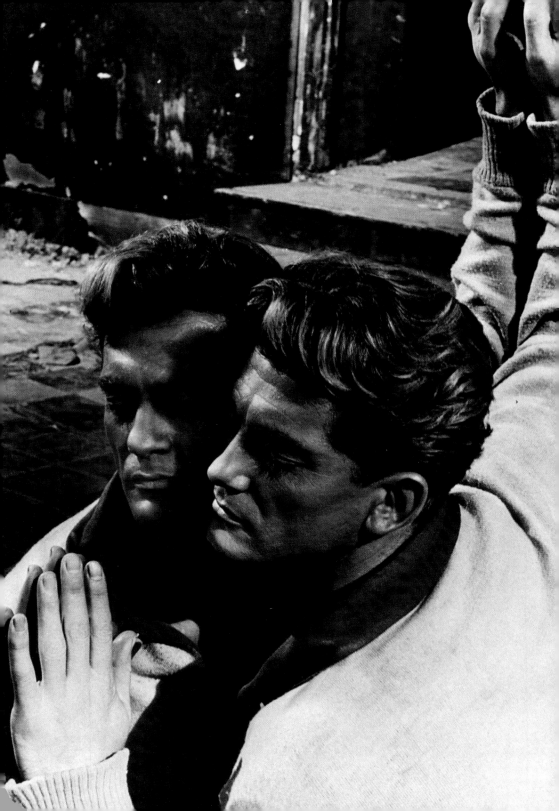

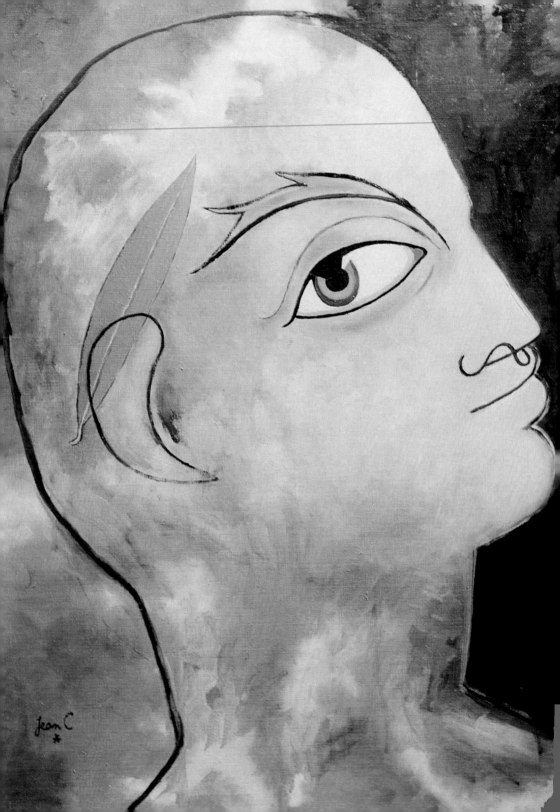

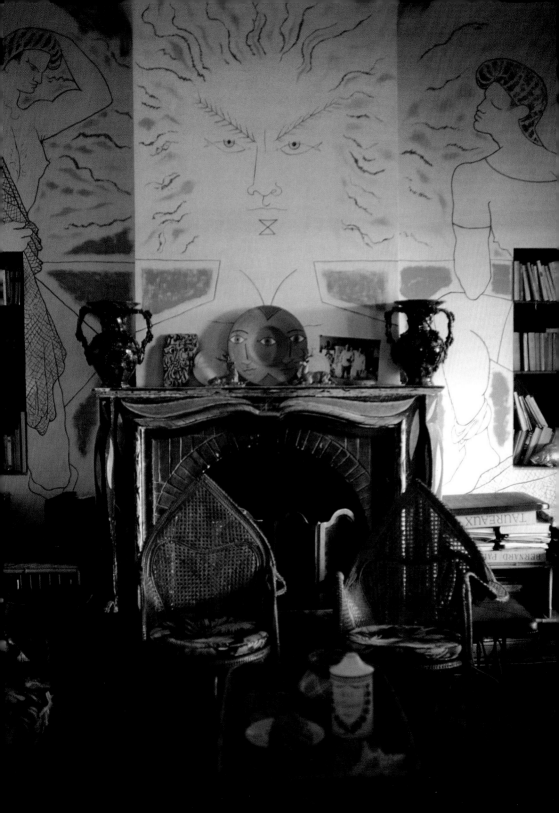

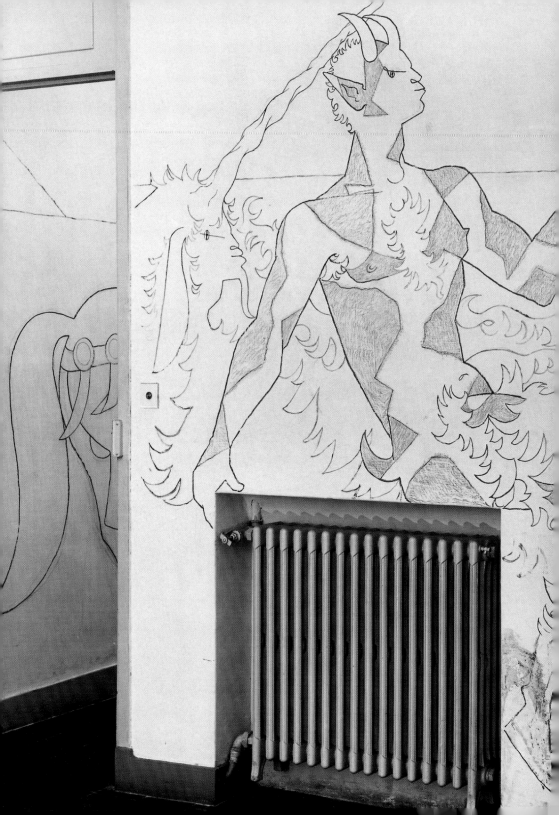

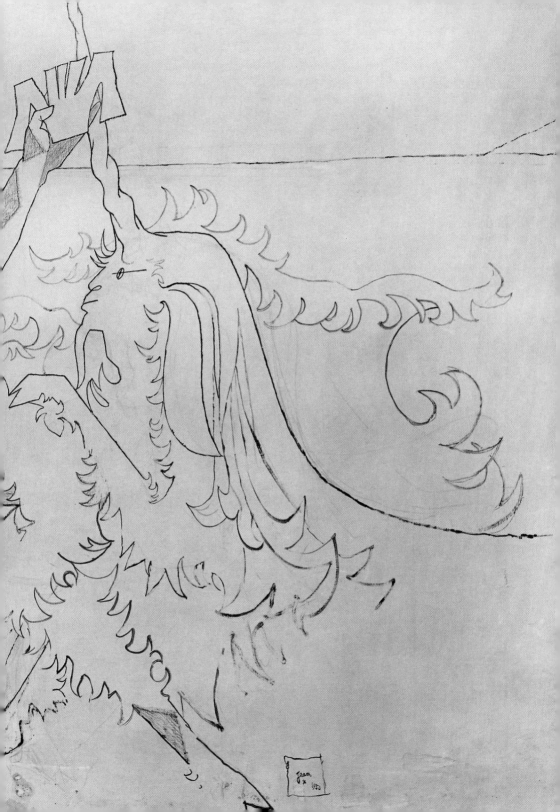

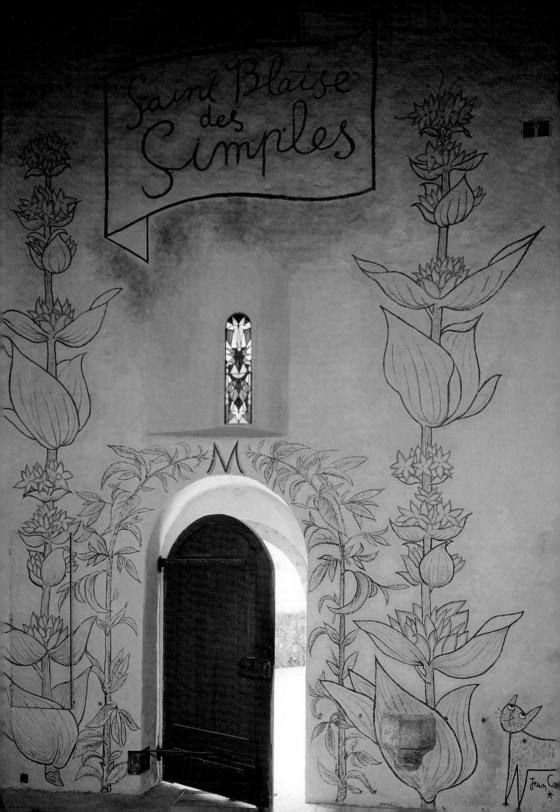

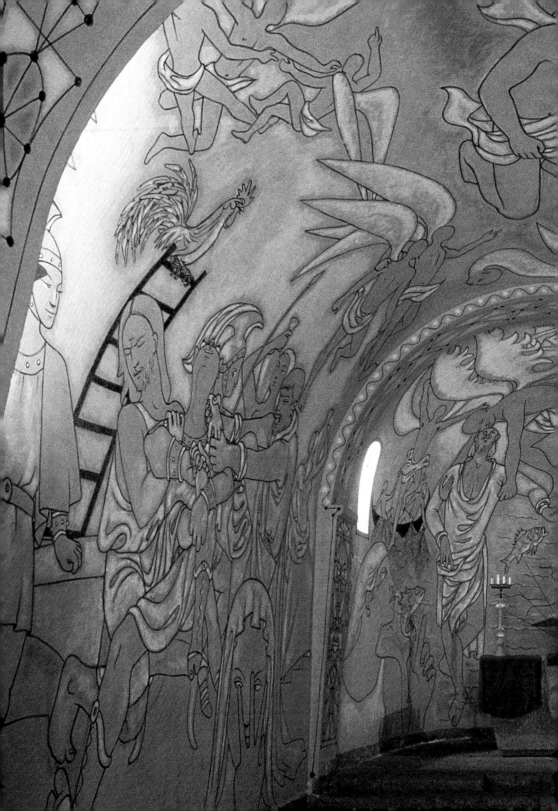

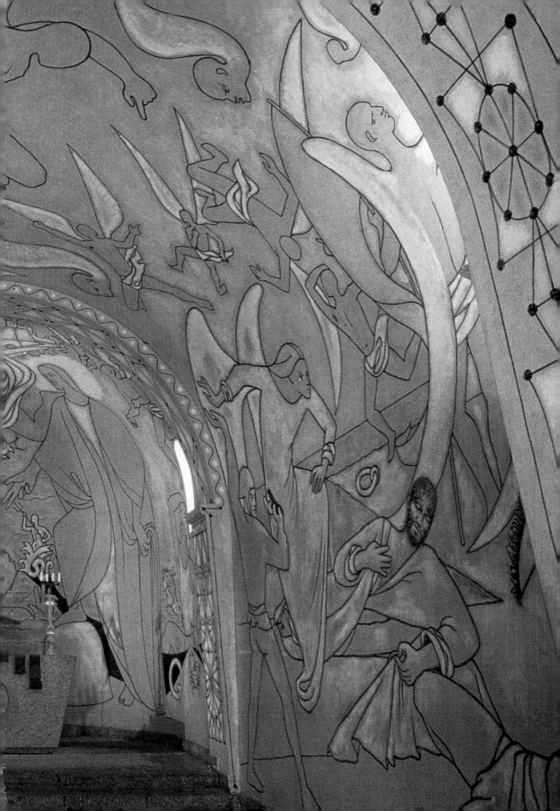

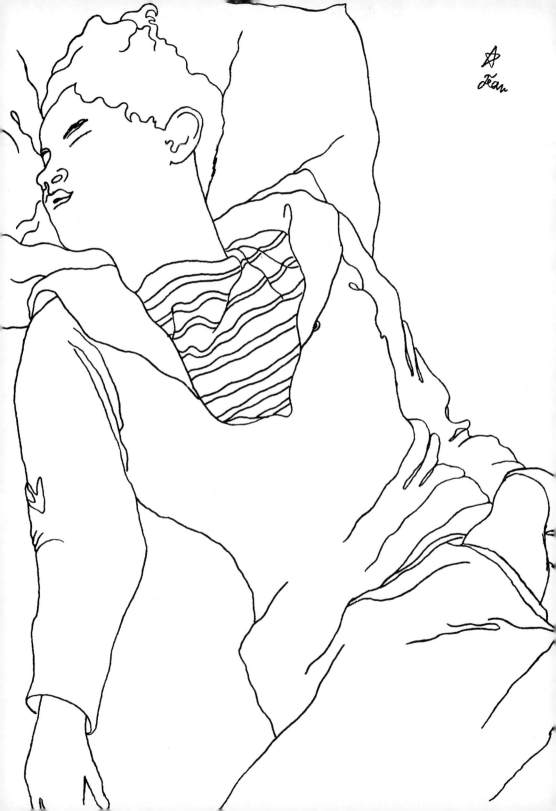

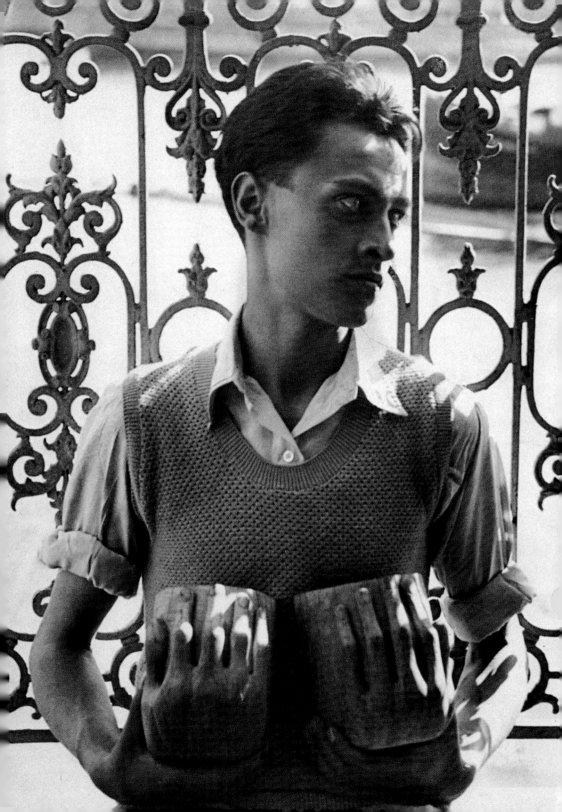

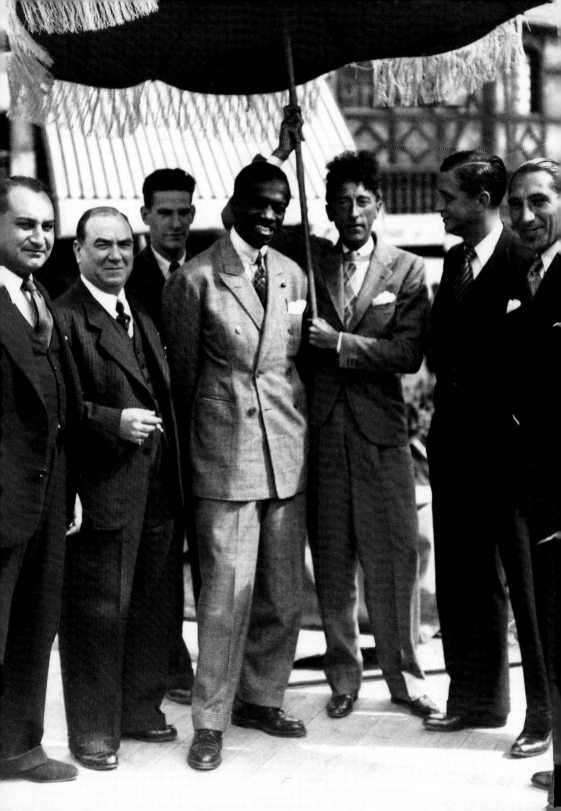

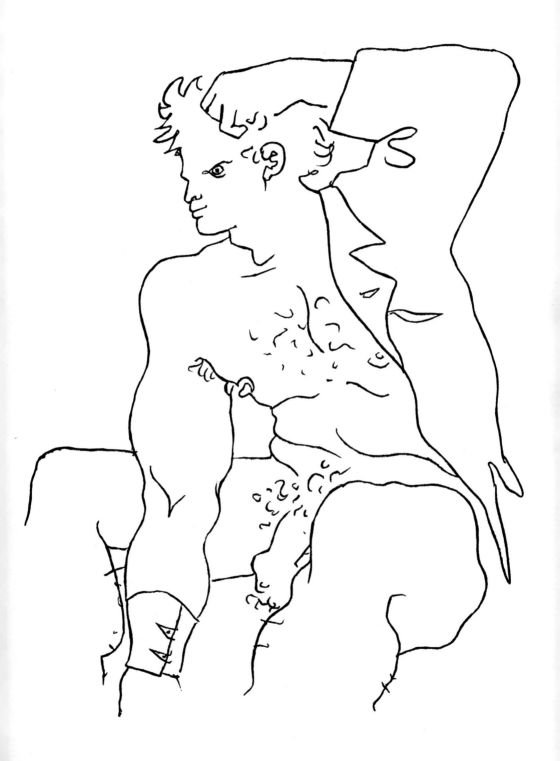

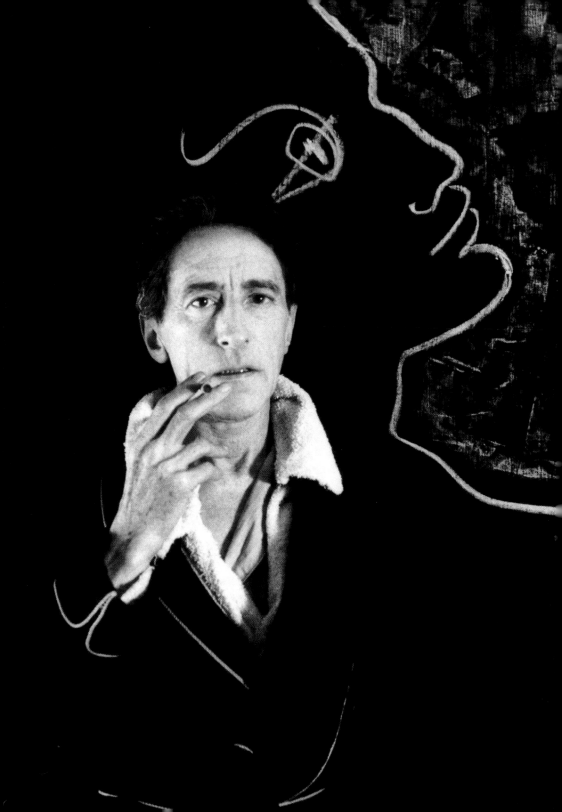

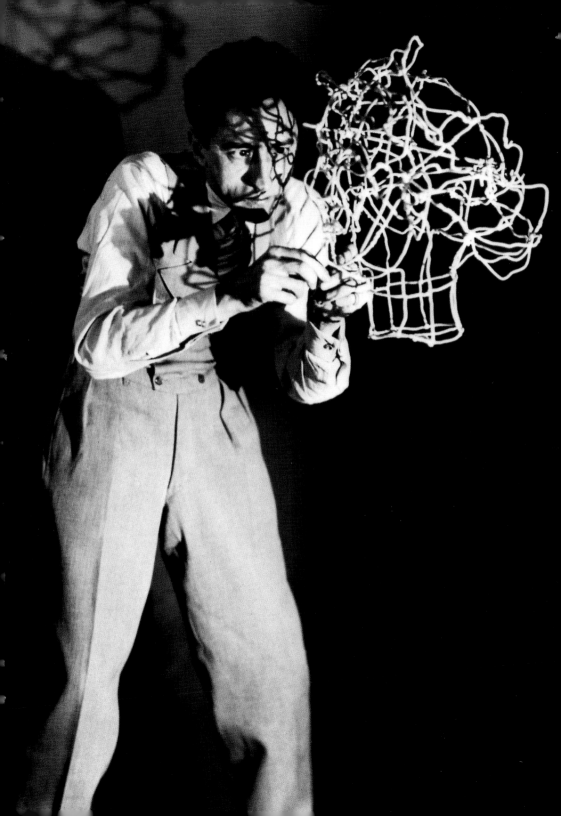

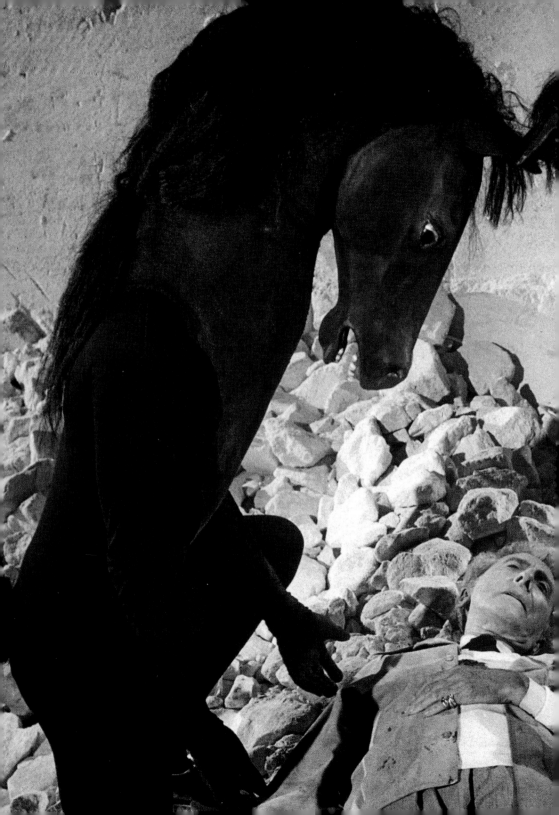

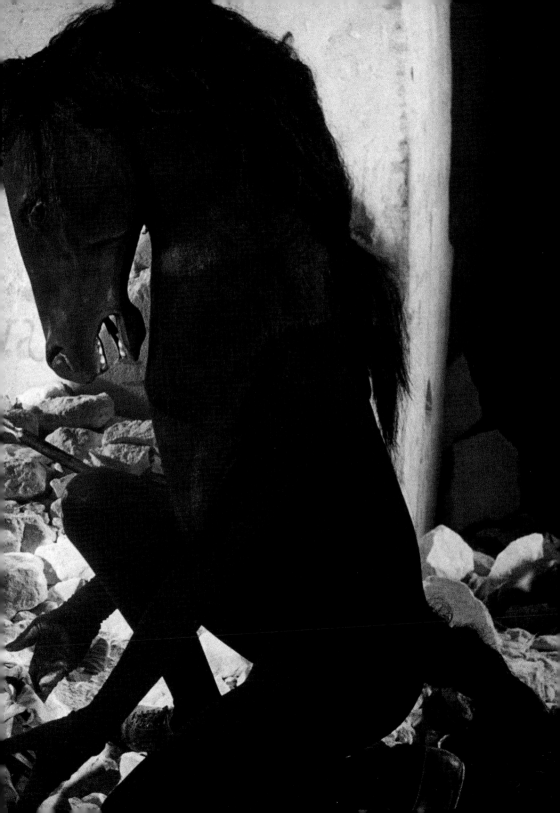

LA MACHINE
INFERNALE

BLANCHARMURE

FAUST

a mon très
cher Louis Jouvet, de
tout coeur Jean

1896

Maintenant, très cher Louis, si vous
êtes habile (malin) Topaze marche - Je
lui ai lu 2 actes (les 2 actes)
et je suis sûr qu'elle veut s'amuser - Il
faudrait votre insistance et votre
entremise - ou proposition d'entremise
auprès des auteurs - directeurs
que sais-je qu'elle est convaincue
de le laisser libre - proposez lui
un coup de main - car elle se place sur
le terrain noble ? C'est justement parceque j'
ai pas de contrats écrits que "
Voyez la - C'est capital (c'est
chanel qui a enlevé
le chose - Le dîner était chez chanel
ce soir -
Je vous embrasse Jean

1000 choses au charmant
et parfait Lahnquier

J'ai un petit ayant de regagner - je serai
auto desigo - Adeline

Béran s'installe chez moi le 15 et fait le
travail d'icon costumes

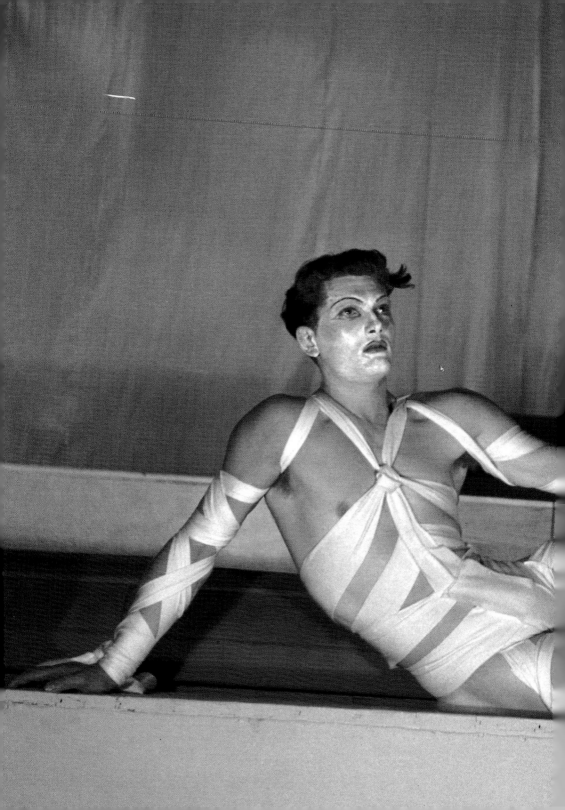

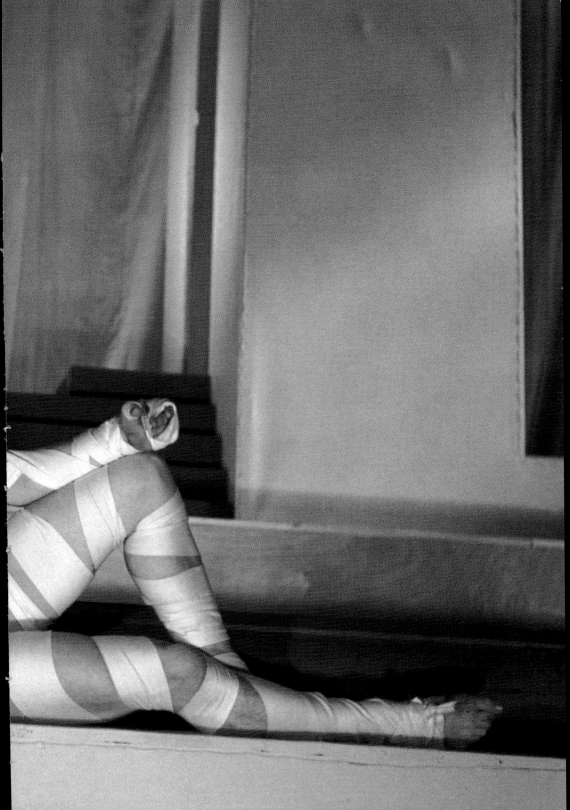

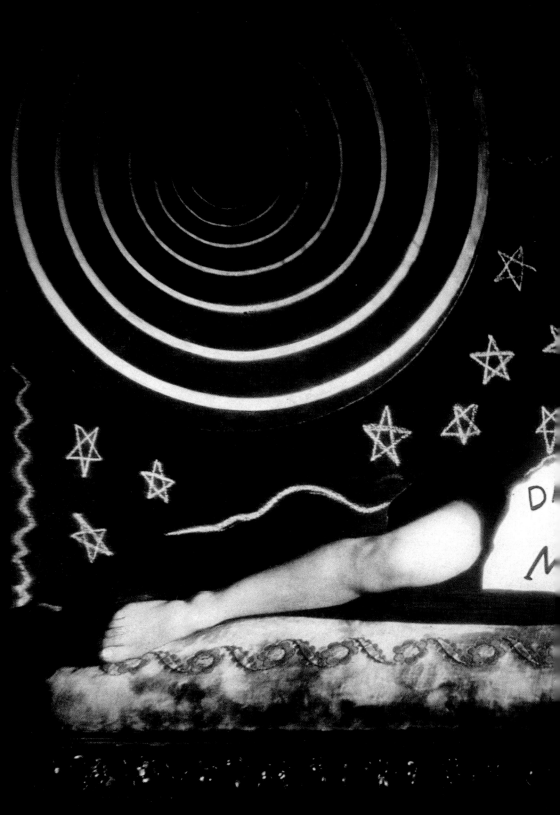

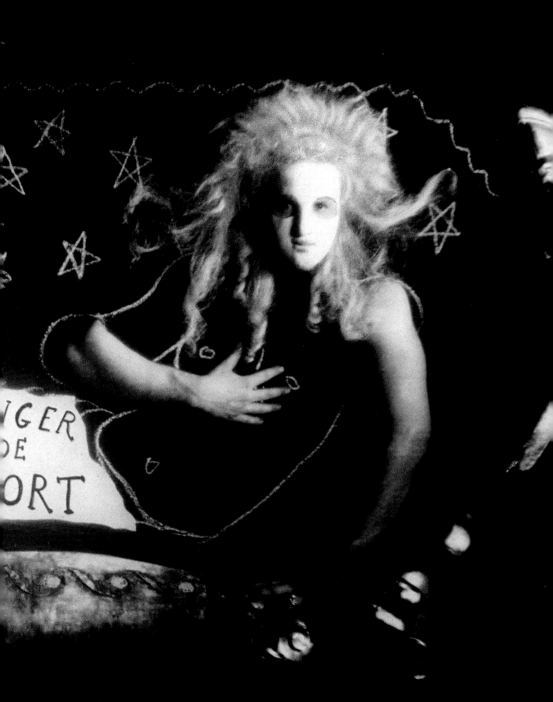

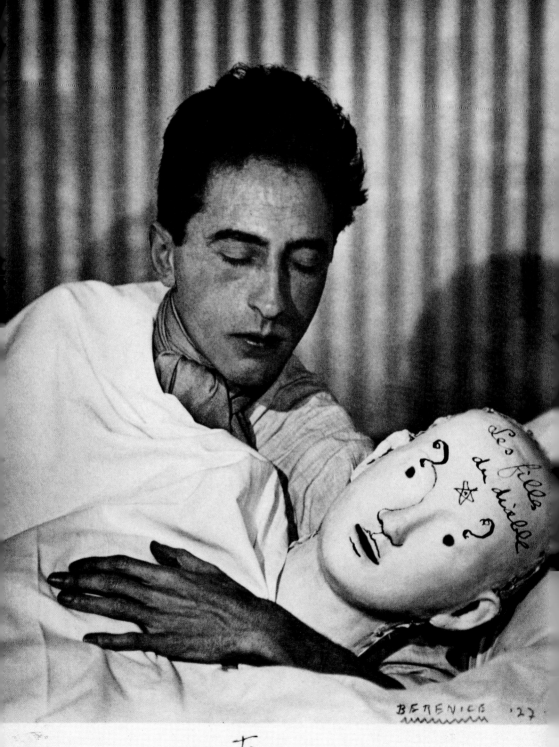

Jean

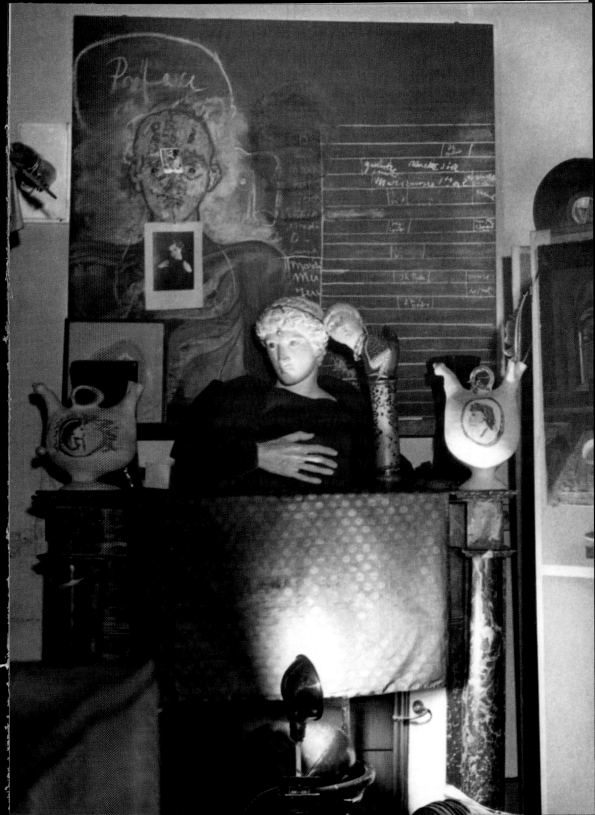

Jean Cocteau

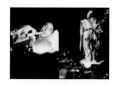

Cocteau the opium addict, photographed by Cecil Beaton. © Sotheby's, London.
Goddess of the moon and guardian of the treasure, the statue of Diana in *La Belle et la Bête* prepares to loose her arrow. © CLT-UFA International.

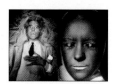

The absent gaze of the poet in *Le Testament d'Orphée* (1960), whose eyes remain wide open even in sleep. © BIFI, Paris.
The hieratic face of Death in *Orphée* (Maria Casarès in 1949). © Photo Roger Corbeau/Ministère de la Culture/AFDPP.

A sketch by Cocteau on a wall at the Villa Santo-Sospir. Private collection. © All Rights Reserved.
Francine Weisweiller, owner of Santo-Sospir, progresses regally through *Le Testament d'Orphée* in an elegant outfit worthy of Cocteau's mother. Private collection. © All Rights Reserved.

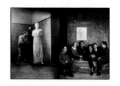

Enrique Rivero talking to the statue in *Le Sang d'un poète*. © BIFI, Paris.
Cocteau with Les Six in 1931. Left to right: Francis Poulenc, Germaine Tailleferre, Louis Durey, Cocteau, Darius Milhaud and Arthur Honegger. Georges Auric, the sixth member of the group, is represented by Cocteau's drawing. © Roger-Viollet.

Lady-friends, lovers and objects of desire: the passions of Cocteau's life. © Roger-Viollet/Private collections/All Rights Reserved.

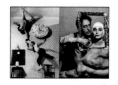

The impossible geometry of *Le Sang d'un poète* is re-created by Philippe Halsman in this 'living painting' of Cocteau and Leo Coleman. © Photo Philippe Halsman/Magnum.
The painter and his model: the confusion of the roles is interpreted here by Philippe Halsman. © Photo Philippe Halsman/Magnum.

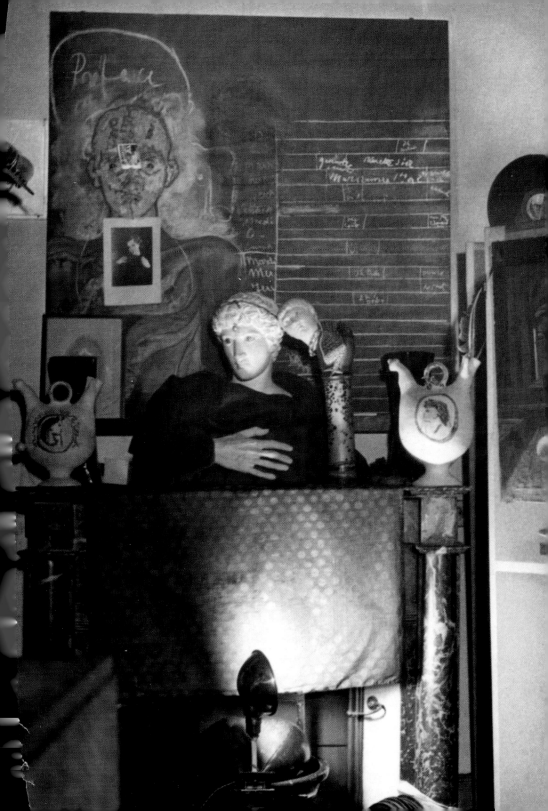

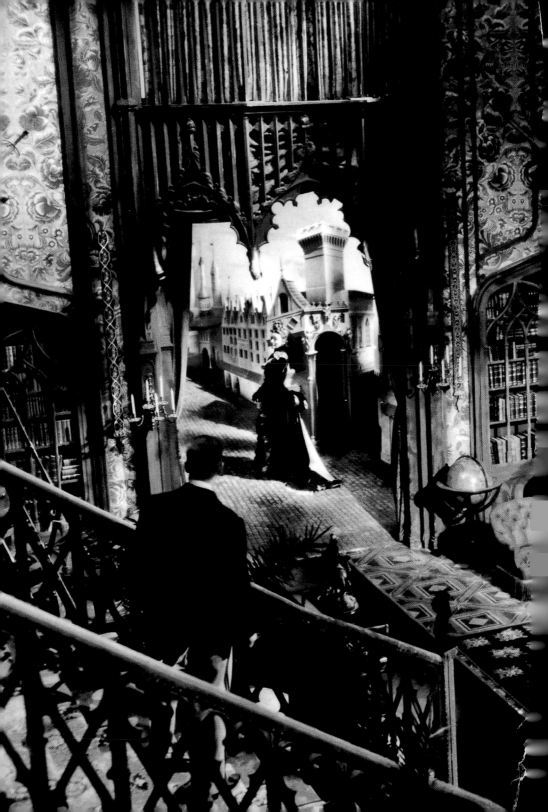

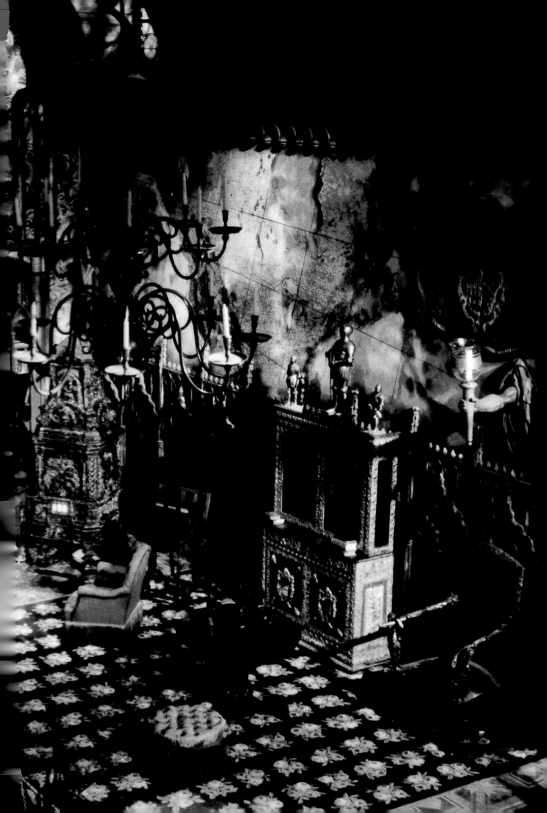

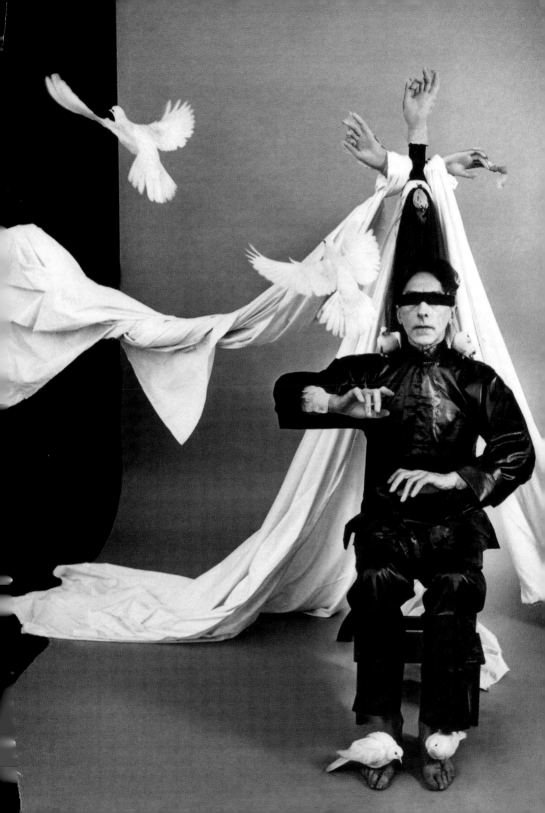

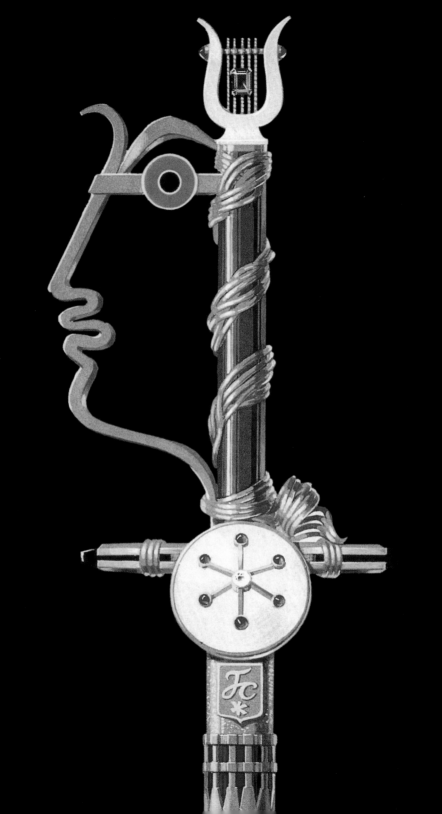

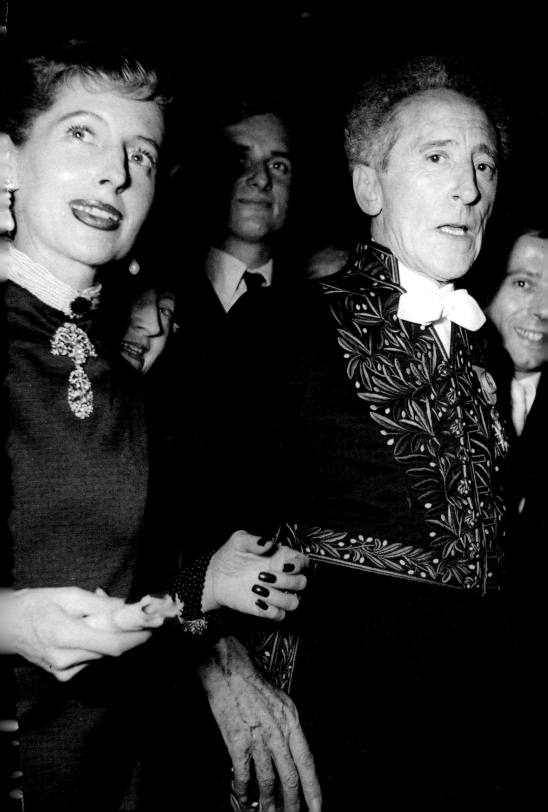

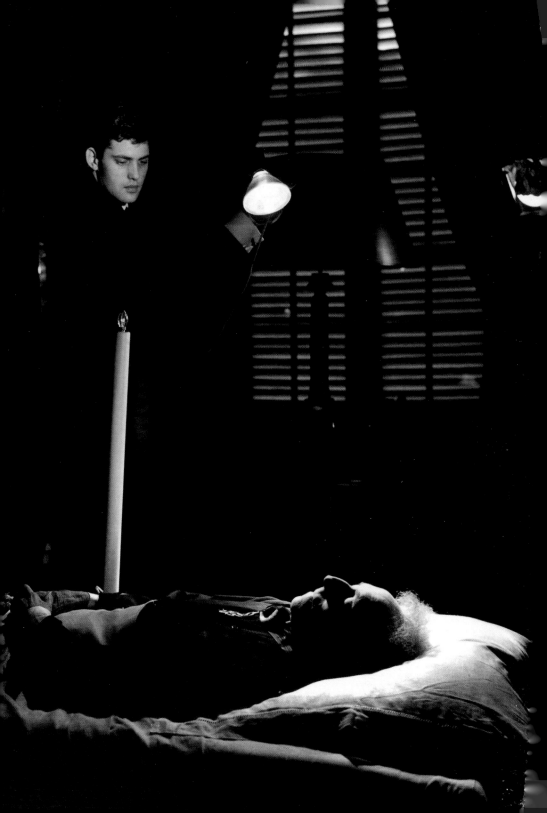

Chronology

1889	Birth of Jean Cocteau in Maisons-Laffitte on 5 July, the third child of the marriage, in 1875, of Georges Cocteau (born 1842), a former lawyer living on a private income, and Eugénie Lecomte (born 1855). Jean is the brother of Marthe (1877–1958) and Paul (1881–1961).
1891–4	The family divides its time between the Lecomte family house in Paris and Maisons-Laffitte. Well before the age of ten, Jean starts drawing.
1898	Georges Cocteau commits suicide at his home, by shooting himself in the head.
1900	From October, Jean attends the Lycée Condorcet, where one of his fellow pupils is Pierre Dargelos.
1904	Expelled from the Lycée, Cocteau moves to the Ecole Fénélon to complete his schooling. The subject matter of his drawings ranges from the theatre to local citizens and dignitaries, and sporting personalities.
1908	At a matinée at the Théâtre Fémina, the actor De Max gives a reading of Cocteau's poems. Cocteau moves into an annexe of the Hôtel Biron, in the rue de Varenne, with Rilke as his neighbour.
1909	In collaboration with Maurice Rostand, Cocteau founds a top-of-the-market review, *Schéhérazade*, which lasts for only six issues. Writes his first collection of poetry, *La Lampe d'Aladin*. At the première of the Ballets Russes at the Châtelet, he meets Diaghilev, Stravinsky and the rest of their circle.
1910–11	Start of a turbulent friendship with François Mauriac. Received at the home of Anna de Noailles.
1912–13	A further poetry anthology, *La Danse de Sophocle*, makes him dream of being awarded a prize by the Académie Française. *La Revue de Paris* publishes six of his poems. The scandal of the *Rite of Spring*: Cocteau allies himself firmly with the moderns, and meets Gide.
1914	Plans the ballet *David*, and founds the review *Le Mot*, with Paul Iribe. During the war, Cocteau serves as an ambulance driver in the Red Cross.
1915–16	Meets Satie and Picasso, and the Montparnasse artists. His first reading of his poem *Le Cap de Bonne-Espérance*. Forms a friendship with Apollinaire.
1917–18	Goes to Rome with Picasso to join Diaghilev's troupe and work on the ballet *Parade*. Writes a critical article on music, *Le Coq et l'arlequin*.
1919	Publication of *Le Potomak*. Cocteau writes for *Paris-Midi*. Meets the young Raymond Radiguet, a turning point in his life.
1920–2	Stages *Le Bœuf sur le toit*. Finishes *Les Mariés de la tour Eiffel*, the première of which is staged at the Théâtre des Champs-Elysées. Writes the play *Antigone* and the poetry anthology *Plain-Chant*.
1923	Radiguet catches typhoid and dies suddenly on 12 December. In desperation, Cocteau turns to opium.
1924	A new ballet for Diaghilev, *Le Train bleu*. Meets Jacques Maritain, with whom he conducts a lengthy correspondence on mysticism and aesthetics. Publishes a collection of drawings dedicated to Picasso.
1925	Meets Jean Bourgoint and his sister Jeanne, bohemians living on the rue Rodier who provide the inspiration for *Les Enfants terribles*. First of many detoxification treatments. *Lettre à Jacques Maritain*; *Orphée*; a sketch for *Œdipe Roi*, the text used by Stravinsky. Meets Christian Bérard.
1926	Start of an affair with Jean Desbordes.
1927–9	Finishes *La Voix humaine* and *Le Livre blanc*. Starts work on *Opium* and *Les Enfants terribles*.

1930	Starts shooting his first film, *Le Sang d'un poète*.
1932	Relationship with Nathalie Paley, wife of the couturier Lucien Lelong. Finishes *La Machine infernale*. Meets Marcel Khill, who becomes his secretary.
1934	Finishes *Les Chevaliers de la Table Ronde*.
1935	His *Portraits-Souvenirs*, accompanied by his drawings, are published in *Le Figaro*, and prove highly popular.
1936	Retraces the itinerary of *Around the World in Eighty Days*, publishing an account in *Paris-Soir*.
1937	Meets the ex-boxer Al Brown and relaunches his career in the ring, with the help of Chanel. At a theatre audition, encounters Jean Marais, with whom he begins an enduring love affair. Last trip with Marcel Khill.
1938	Première of *Les Parents terribles* at the Théâtre des Ambassadeurs, with Jean Marais.
1939	Starts work on *La Machine à écrire*, then *Les Monstres sacrés*. Spends Christmas with Jean Marais on active service.
1941-2	Finishes *Renaud et Armide*. Attends the opening of the Arno Breker exhibition at the Orangerie. Rewrites the screenplay of *Le Baron fantôme*, a film directed by Poligny in which Cocteau also plays the title role.
1943	Shoots *L'Eternel Retour*, which is released in the same year, and finishes the play *L'Aigle à deux têtes*. Meets Jean Genet.
1944-6	Finishes the long poem *Léone*. Directs the film *La Belle et la Bête*, and keeps a diary of its progress. First production of his ballet *Le Jeune Homme et la mort*.
1947	Buys the Maison du Bailli at Milly-la-Fôret, with Jean Marais. Meets the young painter Edouard Dermit, who later moves to Milly. Publication of *La Difficulté d'être* and *La Crucifixion*. Starts shooting the film of *L'Aigle à deux têtes*.
1948-9	Draws his first cartoon for a tapestry, *Judith et Holopherne*. Release of the film of *Les Parents terribles*, to enthusiastic audiences. Shooting of *Orphée*. Melville adapts *Les Enfants terribles* for the cinema.
1950	First visit to the Villa Santo-Sospir at Saint-Jean-Cap-Ferrat, which he later decorates with frescoes.
1951	Starts *Le Passé défini*, the journal he keeps until his death. Starts work on the play *Bacchus*, which opens in the same year.
1952	Exhibition of pictorial work in Munich and Berlin. Writes the *Journal d'un inconnu*, the poem *Le Chiffre sept*, and works on a new ballet, *La Dame à la licorne*.
1953	Officiates as president of the Cannes Film Festival. Prepares the anthology *Clair-Obscur* for publication.
1954	Attends the Feria in Seville, the inspiration for *La Corrida du 1er mai*. Executes *Les Astrologues*, a masterly series of pastels, a new medium for Cocteau.
1955	Attends a reception at the Académie Française on 20 October, in the presence of Jean Genet.
1956-7	Works on frescoes for the chapel of Saint-Pierre at Villefranche-sur-Mer and the Registry Office at the town hall in Menton. Tries his hand at pottery, and attempts a new poetic style in *Paraprosodies*.
1959	Decorates the small chapel of Saint-Blaises-des-Simples at Milly-la-Fôret and Notre-Dame-de-France in London. Directs *Le Testament d'Orphée*.
1961	Series of *Innamorati*, drawings in coloured crayon. His last book, *Le Cordon ombilical* recalls characters from past works.
1962	In spite of health problems, pursues tireless activity on many fronts: stained glass, sets and costumes, painted panels, readings, checking proofs.
1963	Jean Cocteau dies on 11 October at Milly-la-Fôret; his funeral takes place on 16 October. On 24 April of the following year, his body is laid to rest in the chapel of Saint-Blaise-des-Simples.

In the fantastic passageway created by Christian Bérard for *La Belle et la Bête*, the scene is illuminated, exactly as requested, by 'arms of light'. © CLT-UFA International.

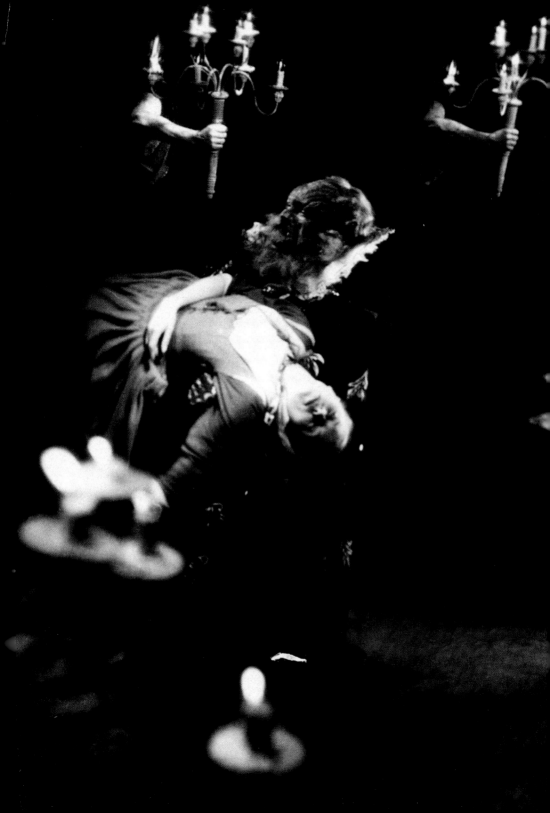

Jean Cocteau

Cocteau the opium addict, photographed by Cecil Beaton. © Sotheby's, London.
Goddess of the moon and guardian of the treasure, the statue of Diana in *La Belle et la Bête* prepares to loose her arrow. © CLT-UFA International.

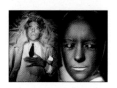

The absent gaze of the poet in *Le Testament d'Orphée* (1960), whose eyes remain wide open even in sleep. © BIFI, Paris.
The hieratic face of Death in *Orphée* (Maria Casarès in 1949). © Photo Roger Corbeau/Ministère de la Culture/AFDPP.

A sketch by Cocteau on a wall at the Villa Santo-Sospir. Private collection. © All Rights Reserved.
Francine Weisweiller, owner of Santo-Sospir, progresses regally through *Le Testament d'Orphée* in an elegant outfit worthy of Cocteau's mother. Private collection. © All Rights Reserved.

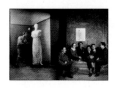

Enrique Rivero talking to the statue in *Le Sang d'un poète*. © BIFI, Paris.
Cocteau with Les Six in 1931. Left to right: Francis Poulenc, Germaine Tailleferre, Louis Durey, Cocteau, Darius Milhaud and Arthur Honegger. Georges Auric, the sixth member of the group, is represented by Cocteau's drawing. © Roger-Viollet.

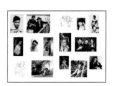

Lady-friends, lovers and objects of desire: the passions of Cocteau's life. © Roger-Viollet/Private collections/All Rights Reserved.

The impossible geometry of *Le Sang d'un poète* is re-created by Philippe Halsman in this 'living painting' of Cocteau and Leo Coleman. © Photo Philippe Halsman/Magnum.
The painter and his model: the confusion of the roles is interpreted here by Philippe Halsman. © Photo Philippe Halsman/Magnum.

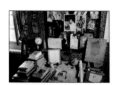

Baudelaire, Radiguet, Picasso, Jean Marais, the image of Cocteau's mother on her deathbed: elements of the informal display above Cocteau's desk at Milly-la-Forêt. © Photo Pierre Jahan.

Cocteau in 1934: making up Greek mythology. © Roger-Viollet.
Pure colour and linear precision, this lithographed poster (an advertisement for the *Théâtre Complet*, 1957) has all the spontaneity of a freehand drawing. © ADAGP 1998.

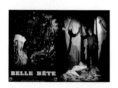

Poster for *La Belle et la Bête*. © ADAGP 1998.
Cocteau wanders through a forest of waving arms, reminiscent of the magic walls in *La Belle et la Bête*, in a photograph by Philippe Halsman. © Photo Philippe Halsman/Magnum.

The impossible conjunctions that lie at the heart of *Orphée* are represented in this collage by Jean Harold used for the poster of the film. © CLT-UFA International.
Jean Marais comes face to face with himself in the surface of the mirror that holds the key to the underworld in *Orphée*. © CLT-UFA International.

Cocteau came late in the day to oil painting. This *Orphée aux lauriers* dates from 1951 (80 x 65 cm, Milly-la-Forêt, private collection). © AKG Photo Paris/ADAGP 1998.
The 'tattooed' walls of the Villa Saint-Sospir are complemented by ceramics and wicker furniture. © Editions Assouline/ADAGP 1998.

The Faun, the image of unleashed animal desire, haunts Cocteau's work; it is shown here as it appears on the walls of the Villa Saint-Sospir. Private collection. © All Rights Reserved.

Lithograph for the chapel of Saint-Pierre at Villefranche-sur-Mer (1957), in two colours (75 x 52 cms) © ADAGP 1998.
The chapel of Saint-Blaise-des-Simples at Milly-la-Fôret (1959), like the chapel of Saint-Pierre, occupied Cocteau's last years. © Photo Jérôme Da Cunha.

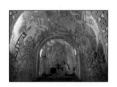

The interior of the chapel of Saint-Pierre at Villefranche-sur-Mer houses one of Cocteau's most successful mural sequences. © Photo Harry Gruyaert/Magnum/ADAGP 1998.

Drawing of Jean Desbordes taken from *25 Dessins d'un dormeur* by Jean Cocteau (Lausanne, Mermod, 1929). By kind permission of Fanfan Berger, Paris. © All Rights Reserved.
Jean Desbordes, minstrel and object of desire. Anonymous photograph. By kind permission of the Librairie Serge Plantureux, Paris. © All Rights Reserved.

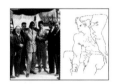

Cocteau, mentor of Al Brown the boxer, whose career he helped to relaunch. © Roger-Viollet.
One of the 'figures made flesh'. Wood engraving for the Morihien edition of *Le Livre blanc* published in 1946. © ADAGP 1998.

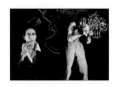

Everyday items transformed into works of art: Cocteau with a chalk drawing, as seen by Man Ray in 1931. © Documentation du MNAM, Centre Georges Pompidou/ADAGP 1998.
Cocteau with a pipe-cleaner sculpture, as seen by Herbert List in 1944. © Photo Herbert List/Magnum.

The Poet watched over by creatures who are half man and half horse, the dark psychic powers in *Le Testament d'Orphée*. © BIFI, Paris.

Writing is drawing joined up differently: a humble postcard (sent to Louis Jouvet in 1934) transformed into a work of art. © Photo Patrick Lorette/BNF, Arts du spectacle, Fonds Jouvet/ADAGP 1998.
A letter from Cocteau to Louis Jouvet about *La Machine infernale*, 1933–4. © Photo Patrick Lorette/BNF, Arts du spectacle, Fonds Jouvet/ADAGP 1998.

Jean Marais in the costume, daringly minimal for its day, designed by Chanel for the production of *Œdipe Roi* in 1937. © Roger-Viollet.

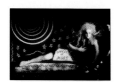

The transvestite Barbette played the role of the Hermaphrodite in *Le Sang d'un poète*. Cocteau was fascinated by Barbette's bodily transformations and wrote an article about him. © Canal+ Images International.

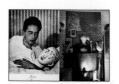

Cocteau was a prized subject for the photographers of the period, from Cartier-Bresson to Halsman. Here he is viewed through the lens of Berenice Abbott, in 1927. © AKG Photo Paris.
All Cocteau's interiors were superbly crafted, their effect enhanced by discreet stage management and the montage, or collage, of everyday items (viewed here in 1934). © Roger-Viollet.

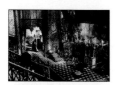

High angle shot by Raymond Voinquel of the set of *L'Aigle à deux têtes*, which brings out the full magnificence of the Gothic cave created by Bérard (the two principal actors are just visible: Jean Marais and Edwige Feuillère). © Photo Raymond Voinquel/Ministère de la Culture/AFDPP.

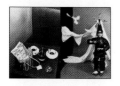

A coffee table shared by Cocteau and Jean Marais. © Roger-Viollet.
A vision of Cocteau by Philippe Halsman. © Photo Philippe Halsman/ Magnum.

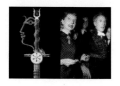

Cocteau's academician's sword, which he designed himself, was made by Cartier. Private collection. © All Rights Reserved.
Cocteau attending a reception at the Académie Française in his regalia, with Francine Weisweiller. © Photo André Ostier.

Acknowledgments

The author would like to express his gratitude to
France Le Queffelec, Fanfan Berger and Julie David.
The publishers would like to thank Francine Weisweiller,
Steeve Giraud and Catherine Couton Mazet for their assistance
in assembling this book. Thanks also are due to Nathalie Biancolli
(CLT-UFA International), Marie-Christine Biebuyck and Clémence
René-Bazin (Magnum), the BIFI, Nicole Chamson and Arlette
Deschaintres (ADAGP), Delphine Desveaux (Roger-Viollet),
Martine Detier and Xavier Rousseau (Sipa Press), Frédéric Doat
and Pierre Pigaglio (AFDPP), Lydia Cresswell-Jones (Sotheby's,
London), Noëlle Guibert (BNF), France Le Queffelec
(Le Promeneur), Bernard Garrett and Hervé Mouriacoux
(AKG Photo Paris), Ode Pena and Angélique Himeur (Canal+
Images International), Serge Plantureux (Librairie Serge
Plantureux), Christine Sorin (Documentation du MNAM, Centre
Georges Pompidou), and the photographers Jérôme Da Cunha,
Pierre Jahan and Patrick Lorette. Finally, particular thanks are due
to Fanfan Berger (whose Galerie Anne Julien at 14 rue de Seine,
75006 Paris contains a permanent display of Cocteau's work)
and Annie Guédras (Association des Amis du
Musée Jean Cocteau, Milly-La-Fôret).